HAUNTED
LOWER EASTERN SHORE

SPIRITS OF SOMERSET, WICOMICO AND WORCESTER COUNTIES

MINDIE BURGOYNE FOREWORD BY G. RAY THOMPSON, PhD

Published by Haunted America
A Division of The History Press
Charleston, SC
www.historypress.net

Copyright © 2016 by Mindie Burgoyne
All rights reserved

Images are courtesy of the author unless otherwise noted.

First published 2016

Manufactured in the United States

ISBN 978.1.62619.809.8

Library of Congress Control Number: 2016941434

Notice: The information in this book is true and complete to the best of our knowledge. It is offered without guarantee on the part of the author or The History Press. The author and The History Press disclaim all liability in connection with the use of this book.

All rights reserved. No part of this book may be reproduced or transmitted in any form whatsoever without prior written permission from the publisher except in the case of brief quotations embodied in critical articles and reviews.

For my little Miss Muffet, who was never frightened away by a scary story.

You have stolen my heart, sweet girl.

CONTENTS

Foreword, by Dr. G. Ray Thompson	7
Acknowledgements	9
Introduction	11
The Pocomoke River	13
The Pocomoke Forest	23
Pocomoke City	43
Snow Hill	53
Haunted Firehouses	63
Wicomico Spirits	71
Old Princess Anne and Teackle Mansion	83
Crisfield Haunts	95
Marion Station	113
Afterword	121
Bibliography	123
About the Author	127

Foreword

A lover of the Eastern Shore, its history and traditions, Mindie Burgoyne, in *Haunted Lower Eastern Shore: Spirits of Somerset, Wicomico and Worcester Counties*, has captured, in a skillfully written narrative, an intriguing story of the Lower Eastern Shore. While she emphasizes the folklore, folk traditions and rich heritage of the Eastern Shore, her monograph might well be read merely for the sheer readability of its history. Again and again, historic homes and sites and their inhabitants spring to life as she recounts the history and legends that surround them. Not satisfied to tell a "tall tale," Mindie has spent incredible amounts of time researching the stories that seem to flow from her pages. Not only has she spent time in research facilities throughout the Shore, but she has also gone to each of the sites she describes, trying to get a "feel" for the place and story she has chosen to detail. People of all ages will be delighted with the many stories she recounts. Many will be tempted to jump into their cars and find their way to the old homes or sites, hoping to retrace the story she has told and looking up at that second-story window to see if indeed a face is peeking out from behind the closed curtain or whether some other unique feature will become visible to them. A combination of history, folk tale and guidebook, Mindie's book will satisfy the curiosities of many readers. (Just as exciting is an opportunity to join Mindie or her staff on one of her famed tours of the Lower Eastern Shore. My wife, daughter and I took one of those tours—unknown to Mindie—and found ourselves enamored by the thoroughly researched presentations of the walking tour we attended and are searching for yet another tour to take.)

Foreword

Even those who are not familiar with local folk tales will be drawn into the many stories Mindie has included in this work. Written to educate, not frighten, her readers, Mindie has woven various folk stories into a larger history of the Lower Eastern Shore. In this way, she shows the importance of such stories to the local area. Those of us who are "come heres" will have heard references to many of the stories that she describes in detail. Mindie's research turns those scant references into fleshed-out stories.

A bright and insightful writer, Mindie uses her strength with words to pull her readers into the stories she tells. Reading her book is like sitting down and listening to her as she excitedly tells one story after another. We see the big picture at first; then, increasingly, we are pulled closer and closer to the site or event she is detailing. Who'd have thought that the Pocomoke River could have a story so fascinating as the many-faceted tapestry spun by the author. Yet Mindie has done just that—she has made the ordinary extraordinary. Her thorough research has added so much to each of the folk stories she has penned.

The vague outlines of the stories of the river, forest, city and village, and of houses and individuals, are recognizable to many Eastern Shore residents. It is the attention to detail that gives these stories their particular vitality. As the author notes time and again in the text, it is the mysterious—the sense of mystery—that so often intrigues people. Fortunately, many of these stories have been preserved in archival facilities throughout the Shore. In particular, the folklore archives at the Edward H. Nabb Research Center for Delmarva History and Culture at Salisbury University have preserved more than thirty years of folklore interviews, many conducted by Professor Polly Stewart and her dedicated students. Mindie Burgoyne has taken these tales and added a rich historical overlay with photographs, creating a most entertaining, yet thought-provoking, series of stories of Delmarva and her ghostly apparitions.

Mindie holds that every bend of each river or every turn of each road on Delmarva holds a story worth telling. Readers will be osmotically "pulled into" the stories in this monograph. This book clearly demonstrates the love that Mindie holds for the Shore, its people, its historic sites and its folk tales.

G. Ray Thompson, PhD
Professor of History,
Co-Founder and Director of the Edward H. Nabb Research Center for Delmarva History and Culture,
Salisbury University, Salisbury, Maryland, April 2016

Acknowledgements

I want to sincerely thank the dozens of historians, librarians, citizens and friends who shared their stories and helped me uncover the truth that lives beneath the folklore. I offer deep gratitude to the people at the Edward H. Nabb Research Center for Delmarva History and Culture at Salisbury University—not just those who helped me comb through files but all the Nabb volunteers past, present and future, as well as those who have donated collections, financial contributions and time. Thank you. You have helped to create something that matters—something that continues to give back to the community.

I extend my sincerest thanks to Dr. G. Ray Thompson, whose leadership and vision have shaped the Nabb Center into becoming one of the most powerful resources for understanding regional history and culture. I have never spoken to this wonderful man and not received some kind of compliment or word of encouragement. Dr. Ray is one of the great ones. He lifts others up, always focusing on giving and supporting.

To the scores of people who allowed me to interview them by phone, by e-mail, through social media or in person, thank you. I salute the Princess Anne Police Department not only for its support, its stories and gracious welcome but also for taking the time to do the little things that matter, like welcoming guests to the town, offering directions and returning lost keys. You are a class act. To the citizens and town staff in Pocomoke City, the Town of Snow Hill, City of Crisfield and City of Salisbury; to Julie Widdowson from Somerset County tourism and her staff; to Lisa Challenger from Worcester

Acknowledgements

County tourism; and my dear friend Lisa Ludwig and the Lower Eastern Shore Heritage Council, thank you all for reaching out to me, for escorting me around your towns, for introducing me to your storytellers and for your warm welcome. This book reflects all that you have shared. Your efforts are the foundation on which these stories rest. They were your stories. But you allowed them to become everyone's stories.

I extend my thanks to Hannah Cassilly at The History Press for her patience in working through this project with me and to my lovely cousin Anita Stevens, who helped with the editing, as well as Julie Messick, who also did editorial work on this book. I'm deeply grateful. To all of our storytellers on the Chesapeake Ghost Tour team—Missy, Maria, Amanda, Christopher, Fran, Mary Beth, Toni and Jefferson—I'm so grateful for each of you and how you make the ghost stories come alive. To my daughter, Lara Marie, who is the tether between all of our ghost tour guests and our company, thank you for your kindness, thank you for always answering the ghost phone, thank you for your competency and thank you for being someone I can always depend on.

To my family and close friends, thank you for tolerating my whining and complaining about hating to write and feeling like I'd never finish this book. Your encouragement is so important. It keeps me going. It's the fuel for my engine, and although I may not show it, I treasure your support.

Finally, to the man of my dreams, my husband and soul mate, Dan Burgoyne, thanks for being my support, my rock, for making me laugh every day, for knowing when to listen and when to give advice—okay, let's face it, I'm never going to take advice. But thanks for being willing to offer it, my darling, and for loving me unconditionally and for coloring my life with so much happiness. You are always the audience that I have in mind when I write. I love you so.

INTRODUCTION

All great literature is one of two stories; a man goes on a journey or a stranger comes to town.

—Leo Tolstoy

Fourteen years ago, my husband and I moved from a Washington, D.C., suburb to the Lower Eastern Shore. At the time, we were in a position to move anywhere we wanted. We had owned a summer home on the Tangier Sound in Somerset County and had fallen in love with the lower shore landscape. We were so moved by the peace that we found in the surroundings there that we chose the Lower Eastern Shore as a place to live for the rest of our lives. I thought it was the shoreline, the marshes, the waterfowl, the historic towns and the big skies that were the draw. But it wasn't until I took a job in the small town of Snow Hill that I started to realize that there was an invisible pull, a secret magnetic draw that pulsed beneath the landscape. It drew me to this region and keeps me here.

It's the stories. Little by little, they entice you. They weave you into the landscape so that it's hard to leave. Around every turn, every bridge, every dirt road, every old homestead, every country store and every rusted out tractor, there is a story. And by keeping the stories alive, the old spirits stay on. I half expect to see Elizabeth Teackle walking past the second-story window of Teackle Mansion with candle in hand, meet Sampson Harmon and his cat on the nature trail near Furnace Town, hear little Annie Connor's cries around the bridge at East Creek or catch a glimpse of "Old Rock" behind

Introduction

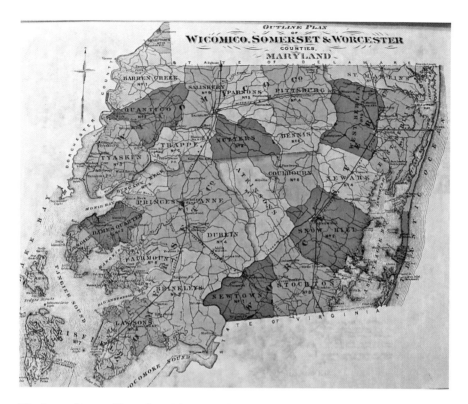

The Lower Eastern Shore, from *Maryland: Wicomico—Somerset—Worcester Counties 1877*. *Courtesy of the Edward H. Nabb Research Center.*

the bar at Headquarters Live. The best ones are the scary ones. Who knew about the crazy lights in the Pocomoke Forest or the spirits that reach out and touch you at the Mar-Va Theater? Some of the most alarming and unnerving haunted sites in the Mid-Atlantic are tucked away on the Lower Eastern Shore. The region is dotted with haunted mansions, phantom cries of lost children and anguished mothers, ghost ships that sail the Chesapeake Bay and spirits that can't let go of the homes they loved. It's like living in two worlds. The stories surround you. The stories become you.

This book contains my favorite Lower Eastern Shore ghost stories and tales of the dead. I hope you will enjoy reading the stories as much as I enjoyed discovering them.

The Pocomoke River

Wending its way through central Worcester County is the intriguing, deep, curvaceous and historic river, the Pocomoke, which meanders across comparatively flat terrain forty-five miles in length.
—Worcester County, Maryland's Arcadia

There's something about water. One of the four natural elements, water covers 71 percent of the earth's surface and has a receptive energy. It's always moving, cleansing, cooling, warming, quenching, reflecting, softening the rough edges and rendering burdens weightless. Water has a healing, sacramental quality. Just looking at water eases our conscious mind—usually. People pay hundreds of thousands of dollars to buy homes with water views. There's some primal quality about water that touches us, draws us to it and moves us to replicate what we see in paintings and photographs. Great songs and ballads have been written about rivers and bays and cultures that grow up around them. Hearing the names Mississippi, Shenandoah, Rio Grande and Colorado—each name conjures up romantic images, thoughts, stories and songs about a particular place with a character that is solely its own. Every river has a story.

The Pocomoke River in lower Worcester County has its stories, too, and they are almost always laced with mystery and horror—vanished fishermen, drowned sea captains, murdered wives, abandoned children, escaped slaves and non-human spirits that live in the forest along the river's edge. It's one of Maryland's most mystical waterways. Even the name sounds enchanting.

Haunted Lower Eastern Shore

The Pocomoke River.

Most historians believe that the name Pocomoke derived from an Algonquian term meaning "black water," which is apropos for this river because six feet below its surface there is no ambient light. The water of the Pocomoke is as black as night. The bald cypress trees that grow in the forest and swamps flanking the river leak a dark, tannic substance that gives the river its black color. Drownings were common in the Pocomoke because once victims fell below the surface, they couldn't tell which way was up or down. They were in utter darkness. Even good swimmers panicked and drowned. According to an old newspaper from the 1930s, the river usually claimed three to six victims each year. In her 1970 publication *An Itty Bitty History of Snow Hill, Maryland*, schoolteacher Gladys Gibbons wrote:

> *During my lifetime the Pocomoke River has claimed many lives. I remember hearing about Bill Goodman's uncle Dan. There was Bobby Corddry out rowing one day. He was a high school boy when it happened. Richard and Sarah* [children] *went bathing from their home south of the Col. Westfall property. They were cousins of Francis Leake. Captain Richard Howard lost* [his children] *Virginia and Richard when the Tivoli burned. Mr.*

Spirits of Somerset, Wicomico and Worcester Counties

Carl Phillips' son was drowned. Mr. Walter Price remembered that a man named Johnson Lewis lost his life. Roger Williams and Tobe Gillet were also claimed by the river. There were many others.

The Pocomoke runs about seventy miles from the mouth at the Pocomoke Sound all the way up into the Great Burnt Swamp area in the southern part of Sussex County, Delaware. According to the people in the Earth Mapping Laboratory at the University of Maryland Eastern Shore, the Pocomoke River is the deepest river for its width in the United States and the second deepest in the world, second only to the Nile River.

Pocomoke City has always been defined by the river. The city grew out of a small ferry landing near the mouth of the river. In 1670, William Stevens established a ferry crossing here, and the area became known as Stevens Ferry. After a log meetinghouse was established down by the landing, the town became known as Meeting House Landing. Tobacco was the currency of the day, and eventually a big warehouse for storing it was built at the landing; the town assumed the name Warehouse Landing. But in 1776, coinciding with the start of a new nation, the people of the town on the Pocomoke River officially named the town New Town—eventually, that was shortened to Newtown. That name lasted about one hundred years. The town officially incorporated in 1865, but in 1878, it adopted the name Pocomoke City after the Pocomoke River.

The city became famous for shipbuilding because of the bald cypress trees that are abundant in Pocomoke Forest. The cypress wood can last forever in the waters of the Chesapeake Bay region. Cypress wood is very hard and resistant to corrosion and pests. The Indians first made boats out of cypress trees. They would fell the tree by setting the base on fire, and after it fell, they'd carve out the center, crafting a log canoe. The town became a significant port for trade, and the population thrived. Although the river industry is gone now, the ghosts of the old shipbuilders and sea captains still linger around the river. All along the river—from Pocomoke City to Snow Hill—there are stories of tragedies and freak accidental deaths.

In the late 1890s, at midnight near the Mattaponi Ferry, the ferryman was asleep in his home. A horse and carriage with a sleeping driver came up the road approaching the docked ferry. Since the horse had no one to stop him, he trotted onto the ferry and never stopped. The animal, with no driver guiding it, walked right off the other end of the ferry, dragging the carriage with its sleeping driver into thirty feet of water. Both the horse and the sleeping driver were drowned.

Also around the turn of the twentieth century, there were two brothers fishing for sturgeon on the Pocomoke. They made a catch and hauled the fish into their boat. It was necessary to use a heavy rope net to catch and hold these ten-foot, 150-pound fish. When the fish began thrashing around, the boat capsized, throwing all into the water. The brothers became entangled in the net and drowned as the monstrous fish swam away.

A notable double drowning happened in October 1910 when, in an effort to save his female companion, young Henry Page Dennis of the Beverly plantation in Pocomoke drowned about two miles south of his waterfront home. He was the son of the late senator Samuel King Dennis. His companion was twenty-three-year-old Caroline Eaton, the daughter of a Wisconsin college president. Caroline was visiting Henry Dennis's sister, Mary. Henry and Caroline left Beverly Plantation in a small sailing craft at about 2:00 p.m. on October 15. After sunset, when they didn't return, Henry's brother, Alfred, went looking for them. He found the empty sailboat floating, unmanned, at the mouth of Pitts Creek around 2:00 a.m. The family believed that Caroline must have fallen overboard, and Henry, who was a very good swimmer, jumped in after her and drowned in the struggle to save her. A large force of men dredged the area for days attempting to find Henry and Caroline. They were unsuccessful in recovering the bodies.

A less tragic story occurred earlier in 1910. Postmaster O.J. Lucas of Pocomoke City remarked that sometimes post offices get letters that are undeliverable or to odd addresses such as "Santa Claus at the North Pole." On Wednesday, May 18, 1910, she received one of those odd letters. It was addressed to "Jesus, Heaven." When she traced the letter to the sender, she discovered that it was written by little Olga Wulff, who wanted to write a letter to Jesus thanking him for saving her sister, Vivien, "from being drowned in the Pocomoke River when she felled overboard." Vivien was a lucky survivor.

Not so lucky was the wife and child of Captain Elmer Arrington. On November 22, 1912, Captain Arrington was steering his schooner *Mayflower* into the Pocomoke River. His wife and five-year-old son were on board. A huge fire had broken out on the shore, causing a great commotion in the town. The fire was consuming a barn and threatened destruction of its surrounding structures. Mrs. Arrington lifted her son up so he could see the fire, but she lost her footing and tumbled over the side of the boat with her boy in her arms. Captain Arrington was believed to have been working on the gasoline engine when the incident happened. When he heard his wife's shrieks, he ran to find her, but he couldn't see her

or the boy. Their bodies sank and did not resurface. The poor captain was frantic. After two days, when news of the accident was printed in the Sunday paper, the bodies still had not been recovered despite search parties with grappling irons dredging nonstop.

In 1936, Silas Colona, forty; Frank Dryden, fifty; and William Blackwell, thirty-five—all good swimmers—were fishing for shad one evening from a paddleboat using a bow net. The wind picked up and it started to rain. The boat overturned, and all three men were drowned. According to the local newspaper, only the body of Silas Colona was recovered. The boat was found overturned.

In August 1941, five Maryland Conservation Department boats searched for the body of Maryland's secretary of state, Miles Tawes Tull. He was a young twenty-six-year-old who fell from a boat on the Pocomoke River while trying to fill a bucket with water. Henry Ennis of Crisfield dived overboard to save him but was unable to reach Miles.

These tragic stories were extracted from newspapers on the Eastern Shore, as well as publications in Washington, D.C., Baltimore, Pennsylvania and Ohio, and they are just a sampling of the scores of stories about strong swimmers and their companions who never surfaced after falling into the dark waters of the Pocomoke. There are more stories—longer stories—still told in the communities and around campfires. Some are told for entertainment and some to instill a respect for the dangers of this mysterious river that seems to pluck lives from its surface. Mr. Charles E. Hill, a popular Worcester County auctioneer, used to say, "The river gets one person a year. If it misses a year, it will get two the next."

Captain Job Emmons and the *Arabella*

Certainly one of the most heartbreaking stories is about a man and a boy seen walking on the Pocomoke River's edge. This is not a story told in communities. In fact, it is two stories—one a sighting and one a historical account—but they are strangely similar.

A seventy-five-year-old African American man told a story about an apparition he saw along the river to a folklore student at Salisbury University back in the 1970s. The old man worked at a food processing plant that overlooked the Pocomoke River in an area just east of the Route 13 highway bridge. In his commentary, he stated that sometimes in the early evening,

when the weather was nice, he'd sit outside the plant and take in the river views. There were a few times that he saw a man and a boy walking along the water's edge on the south side of the river. The man wore an old brown coat and hat. Nothing seemed unusual about the sighting, but when the old man saw them walking on a freezing winter's day, with rain and sleet pelting the ground and water, he wondered why they'd be out at such a time, walking so calmly. The old man looked a little closer and saw that the boy wore no coat, and the man wore the same brown coat and raggedy hat that he always wore. When the old man strained to look even closer, it appeared that the two were actually walking on the water.

That image stuck with the old man, and he asked some people if they knew who the walking pair were. It seemed no one else ever saw them. One weekend, the old man took his little boat out to go fishing on the river. He decided to inspect the shoreline where he'd seen the two phantom figures walking and was astonished to discover that the swamp and trees came right out into the river. There was no hard shoreline—no possible place for anyone to walk. The old man closed his commentary by stating that although he never saw the apparition again, he couldn't forget them. The memory of man and boy walking side by side along the river came back to him from time to time. He wished he knew more about them.

When I first read that little story, I found it interesting too. But there were no other accounts of these two walking figures in any of the other stories of folklore about the Pocomoke. I tucked this little remnant away in a Worcester County file and forgot about it. Years later, when I was doing the research for a ghost walk I was crafting for Pocomoke City, I received a folder of files on Pocomoke history from a Pocomoke historian. In the folder was a booklet that was published in 1954 entitled *The Pocomoke River: A Booklet of Personal Memoirs* by Charles C. Kensey. It had a section with the heading "Tragedy on the Pocomoke River." It starts with this entry:

> *In the late 1880s a ten-year-old boy and his father lost their lives at the County Highway Bridge at Pocomoke City. Captain Job Emmons of the schooner, "Arabella" took his son on a trip to Baltimore, Maryland. On their return trip, as the boat passed slowly through the Railroad Bridge, the boy was put ashore to buy something in the town. He was to be at the Highway Bridge to be helped aboard as the vessel passed through. As the captain reached for his son, the boy slipped from his grasp falling between the boat and the bridge. The father plunged into the water after him. But*

they never came back to the surface. Their bodies were dredged up clasped in each other's arms and were later buried at Snow Hill.

I immediately remembered the story told by the old man who worked at the sausage plant. There were some strange similarities. Since I connected these two stories, another coincidence has occurred. Our Pocomoke Ghost Walk actually goes into the Pocomoke Forest for about one half mile. We conduct the tour at night, and the guide stops and tells haunted tales about spirits in the forest. On more than one occasion, various unrelated guests have claimed to see a man with a raggedy hat standing in a clearing in the forest. Even our guide has seen this shadowy figure. And when I was guiding the tour, the man with the hat was seen standing just behind me.

The Cellar House

One can hardly discuss the haunted Pocomoke River without referencing the most famous river story—one that dates back more than two hundred years. It's the story of the Cellar House, a plantation house built in the late 1700s overlooking the Pocomoke River between Snow Hill and Pocomoke City. According to the legend, a French sea captain lived there with his beautiful wife. During this time, Snow Hill was named a Royal Port, and the Pocomoke River was a busy shipping waterway. The Frenchman was a smuggler, and he had a tunnel dug that went from the river to the cellar of his house. Through the tunnel, goods could be smuggled in, stored and shipped out later. Because of this smuggling operation, the house gained the nickname "Cellar House."

When he was out at sea, his lovely wife became lonely. She took a lover, and the two planned to run away together. But the Frenchman returned and caught them together. A fight ensued and the lover was killed, but the wife was able to get away. She was carrying her lover's child, and after she gave birth, she couldn't survive, so she made a plan to head up the Pocomoke River to the Cellar House and throw herself on the mercy of her husband.

It was windy when she headed up the river in a makeshift raft. The current was strong, and the craft became unstable. It overturned, and the woman and her baby fell beneath the black waters of the Pocomoke River. The woman lost her grip on the child, and it slipped away. She was able to swim to shore but was heartsick over her lost child. She knocked on the door

of the Cellar House, and her husband answered. She begged him to forgive her and promised to always stay true to him.

He grabbed her by the hair and dragged her up the steps of the Cellar House into a small second-story bedroom. It was there—on the floor of that bedroom—that the Frenchman stabbed his wife to death. Then, knowing that he would be suspected of the murder and hanged, he loaded all of his stolen goods from the cellar onto his ship and sailed away, never to return. His dead wife was left in the bedroom until she was discovered months later. The fluids from her decaying remains imprinted a perfect silhouette of her body into the wooden floorboards.

Since the murder, there have been sightings of the woman on the riverbank. Sometimes she's heard crying out for her baby. And sometimes the faint sounds of a crying child are heard around the Cellar House. Watermen and recreational fisherman who travel the river at night report these sounds. There are even sightings of the Frenchman lurking in the woods. One story notes that the Frenchman had six fingers and that people who have parked their cars in the Pocomoke Forest have seen the imprint of a six-fingered hand on the car window.

These are old tales that have been retold and repeated over the last two hundred years. But there are interesting things to note about the Cellar House. The tale about the bloodstained floor was very popular. I've noticed this theme in other ghost stories—the bloodstain that wouldn't go away. But there is nothing paranormal or mystical about a stain being left by a dead body. Body fluids from a corpse and blood will permanently stain any wood product. There was a renovation done to the Cellar House in the early 1900s that included replacing the wood floor in only one room of the house—an upstairs bedroom.

Another interesting fact is that the current owners—the Grahams, who lovingly and painstakingly have restored the home to closely resemble its original form—were working on renovations in the cellar when workers came across skeletal remains. The natural assumption was that the bones were the remains of another murder victim—or perhaps the Frenchman's wife or baby. But archaeologists determined that the bones were more likely the remains of a young Native American girl whose family probably lived on the site. Some of the bones were broken before they were buried, and there were some Indian artifacts in the same soil. This was typical for Indian burials of this region. The indigenous people of the Chesapeake region commonly buried their dead and then exhumed them later, cleaned the bones and placed them in a basket, which they buried beneath their

dwelling. When they moved, they dug up the basket and carried the remains of their ancestors with them to their new home. The archaeologist surmised that an Indian house once stood where the Cellar House now stands. These bones in the basement were part of an ancestral burial plot.

For years, the Cellar House has been a public venue for weddings, parties and events. A Salisbury art teacher was teaching an art class for children at the Cellar House a few years ago. She stated that she noticed one of the girls was agitated. The teacher asked the child what was wrong, and the girl replied that she was okay but continued to look around the room, breathe heavily and seem anxious. After a few minutes, the teacher approached the child again and asked her if she was sure everything was okay, and the girl answered that there were dead people all around them.

The Pocomoke Forest

It is a beautiful belief,
That ever round our head
Are hovering, on angel wings,
The spirits of the dead
 —Harriet Beecher Stowe, Uncle Tom's Cabin

When one considers the scariest fairy tales, the most common setting is a thick forest, or maybe a swamp. The setting is so easy to imagine—the sense of isolation, being totally alone with oneself. Human beings tend to reject such experiences. Being alone makes us uneasy. Many people can't stand to be alone. They turn on the television when they fall asleep and have the radio wake them up in the morning. Music plays in their cars and is even stuck into their ears when they walk or cycle. Few people want to be alone—facing only their own company. Distractions blot out that sense of aloneness.

Imagine yourself on your front porch at night. The stars are out, and the moon is shining. All of your neighbors are asleep. All street traffic has stopped. You are alone at your home, experiencing the silence of the night. You stand in the presence of yourself alone. Does this scare you?

Now imagine being on a deserted road in a deep forest. You're on a bridge that crosses a swamp. There are silhouettes of trees growing out of the black water and thick vines hanging from the branches. A bright moon casts some light on the forest, but only enough to see shadows. Nothing is really clear in this landscape. You know that you are completely alone. Nocturnal birds

Entrance to the Pocomoke Forest from Cypress Park in Pocomoke City.

make the only sounds you hear, except for the occasional rustling in the brush—probably made by swamp critters. Why does that setting feel so different? Is being alone in a swamp or a forest the scary thing? Or is it that our senses are keener in a natural setting and we can feel what lies beyond the edges of this physical world more readily when we are surrounded by life forces uninterrupted by development and man-made things?

History is full of references about people leaving the trappings of life and going out into the natural world to find peace for contemplation. The Desert Fathers did it, Jesus did it, the saints did it, and even the indigenous people of America, Africa and Australia all left the comforts of home to find a life force in the wilderness that would strengthen them. But most of these stories describe the contemplative destination as a panoramic open space—a desert, a valley, a voyage or a mountaintop. The images are vast and open and mammoth in size. A forest is the opposite. Even in the daylight hours, the canopy of treetops blocks the light. One can't see too far into the distance. Our imaginations become more active. Tree trunks develop faces. Branches start to look like arms. Every little sound is magnified. Fear sets in—fear of the unknown, the unseen. Forests are all about what we can't see,

what waits in the shadows, what is watching us from a distance. And swamps pose the element of danger—the quicksand or mud that could swallow us up or the black, murky water that is home to snakes and dangerous reptiles.

The Pocomoke Forest is a swampy forest, and it has a two-hundred-year haunted legacy. There are more ghost stories about the Pocomoke Forest than any other wooded area on the Delmarva Peninsula or in the state of Maryland. Although it flanks the Pocomoke River and runs through many communities, it's known locally as "the forest." Pair the ghost stories of the Pocomoke River with those of the forest and it's probably enough for an entire book. The forest is still actively haunted and frequented by paranormal investigators, ghost hunters and teenagers who want to scare themselves. The region has a mystical quality about it—even I have experienced strange events in the forest.

When we guide the Pocomoke ghost walk, we go into the forest for the last half. Many guests have mentioned being "touched" or have gotten strange images in their photos. There is always some paranormal thing that happens on that Pocomoke tour. We've tagged it our "scariest walk." I had a ten-year-old boy on the walk who kept asking his mother if she'd touched him. He was walking behind her, and she kept saying, "How could I touch you if you are behind me?" He was also at the end of the line of walkers on the path. Finally, she moved him in front of her and told him to stay there. Then, halfway through the tour, she pushed her way up to me and said that she wanted to be in front. Later, she admitted that something touched her from behind once she'd told her son to move ahead. She was terrified.

Last year, when I was guiding another tour into the Pocomoke Forest (the tours are all after dark), I stopped on the forest path to tell a ghost story. We were standing on a wooden boardwalk that was built over the swamp, and we were deep inside the forest. I had the guests turn off their flashlights, and in the total darkness, I began telling the story of the Cellar House. Everyone gets a little edgy when I ask for them to turn off their flashlights and discontinue the use of their smartphones or anything that lights up. There's usually someone who just can't do it. They have to have some kind of light. The darkness is unnerving. As I was finishing the story, one of the guests who was dealing with some fear of the dark asked what the white lights were below the boardwalk (in the swamp). I took a closer look. There were little white lights the size of pebbles—similar to Christmas tree LED lights—below the boardwalk in the swamp. They were only about four feet away from where we were standing. At first I thought they were lightning bugs, but they weren't yellow and weren't moving. We all continued to look

and wonder. I took the tip of my umbrella and lowered it over the side of the railing. I stirred it through the brush where the lights were. The stirring didn't affect the lights—they didn't move. The lights almost looked like a moon reflection on flint, but of course, there are no stones in the swamp and there was no moonlight.

I started to say out loud, "I just don't know…," and one guest panicked. Then another guest started to cry out, "What are they, oh my god!" To gain control of the group, I told them that it was swamp gas (hoping they'd never seen swamp gas). This seemed to offer an acceptable explanation, and we moved forward. I stopped at a large clearing in the forest and had everyone gather around me while I told the story of Sampson Harmon and Job Emmons. When I was done with that story, the guests were invited to turn on their lights and explore the area, take pictures and soak in the darkness. It was during this little break that a guest told me she saw a man standing behind me with a hat while I was telling the story. She couldn't see him very well. At first, she thought he was part of the tour, but then he vanished. She was sure that he wasn't on the tour. Normally, this wouldn't have rattled me, but just a few weeks earlier I was doing the same tour and had a ghost tour guide in training who said the same thing. He saw the same figure, with a hat, standing beside me at that same location while I was telling the Job Emmons story. The coincidence left me uneasy.

I started to lead the group out of the forest, and when I got to a turn in the path where the hardwood forest transitions into swamp, I heard a strong rustling in the brush in front of me. It made me jump, and the people behind me screamed. But I calmed them down, and we proceeded out, quickly. There was no stopping, no stories. I couldn't get out of that forest fast enough. While walking, I kept wondering what that rustling noise could have been. It was at my eye level, so it couldn't have been a raccoon. I know deer live in the forest, but no deer would approach a group of twenty-five people walking through the forest, and they can smell humans a mile away. Anything standing behind that brush would have been standing in the swamp. It made no sense.

As I was imagining what could have been behind the brush, we started getting pelted by something from the treetops. Whatever objects were being thrown down hit the boardwalk path and rolled along the slats. I knew that squirrels wouldn't be up pelting humans at 10:00 p.m. I had no explanation. This wasn't a random drop of a nut or stick. They kept coming until we finally exited the forest. The weird moments were adding up. One unexplained event can be a bit daunting, but four? The lights, the shadowy

figure with the hat, the rustling in the brush and the pelting from above—it was a lot in the space of an hour.

After that crazy tour, I now only do the Pocomoke walk when we absolutely have no other guide to do it. The forest scares me. I did another night tour of the forest a few months later when we had no backup guide, and I stopped the group where we saw the lights. I told them about seeing lights, and they all looked over the side of the boardwalk to see if the lights would appear. We didn't see anything. But just as we were about to carry on, an older man who was a guest on the tour said, "Look. There they are." And there they were, just like I had seen them on that previous tour. The same white lights—no motion, no reflection and no movement when the plants around them were moved.

I can't explain the white lights or any of the other strange happenings in the forest. But I think that the environment of a forest swamp, and how it is charged with the natural elements—water, earth and vegetation—with little else in the mix sharpens our intuition and sensibility of other realms. The otherworld pulsates a little closer.

Access to the Pocomoke forest by way of that boardwalk is closed to the public after dark. If you want to go in and experience it yourself, you might consider signing up for one of the ghost walks or checking with the Pocomoke Police Department about gaining access. The entrance to the forest is monitored with cameras, and if they see unauthorized people entering the forest, they will go in and get you.

The Heavy Bible

Shortly after the Civil War, Purnell Pusey and his wife donated some land in the Pocomoke Forest near Furnace Town to the Methodist community. The Old Nazareth Church was built on the site, and it operated for nearly seventy years as a small country church. Members of the Pusey family, as well as others from the community, were buried in the graveyard that flanked the simple church building. In the mid-twentieth century, the Methodist Conference stopped recognizing the small church, and it was abandoned. As time passed, the empty church and graveyard became associated with haunted tales, phantom figures stalking the graveyard, bleeding headstones and other strange happenings. But the most famous of the tales related to this church was that of the "Heavy Bible."

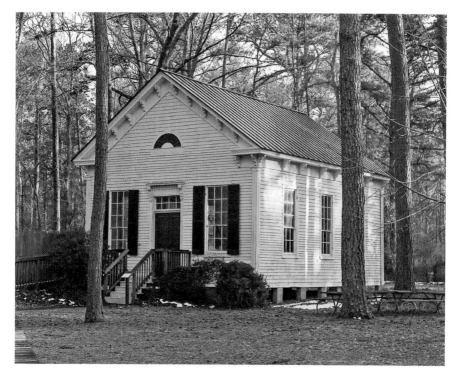

Old Nazareth Church—location of the "Heavy Bible." It now sits on the property at Furnace Town Living Heritage Museum.

The little white church in the woods was said to have a Bible that stayed on a lectern near the altar (different stories vary on where the Bible was placed). If a person lifted the Bible and tried to walk away from the lectern, the Bible would get heavier until it was too heavy for anyone to actually hold. Therefore, it could never be removed from the church. One of the commonly told stories is of two boys who stole their way into the abandoned church at midnight intending to break the spell of the heavy Bible. They removed it from the lectern and started to carry it to the door. The Bible became burdensome, and when the boys got halfway down the church aisle, the weight of the book overpowered them. But when they began to move back in the direction of the lectern, the heaviness lifted. They replaced the Bible and left the church terrified. Another account is of two men who, like the boys, failed to remove the Bible yet still gave it a second try using a wheelbarrow. They rolled the wheelbarrow up to the lectern and carefully place the Bible in it. As they started to push it down the aisle toward the door, the wheelbarrow became too heavy to push. Halfway down, it wouldn't

budge and appeared to be on the verge of collapsing under the weight. As the two men started to pull the wheelbarrow back toward the lectern, the weight lightened and it moved smoothly with no resistance. There are even accounts of men trying to throw the Bible out the window. But when people heave the Bible into the air, tossing it in the direction of an open window, the Bible drops to the floor like a hunk of lead.

There are scores of accounts from people claiming to have tried to move the Bible away from the lectern or altar only to be overcome by the weight. Here are a few of the references to the heavy Bible noted in commentary collected by folklore students at Salisbury University in the 1970s:

> [My uncle] *went to the church and went up to that altar and lifted that Bible up. It didn't seem very heavy, so he started to carry it towards the door. But as he got closer and closer, that blamed Bible, it got heavier and heavier. Then he had this funny feeling come over him, like the chills and shakes, so he walked that Bible right back up and scooted out of that place.*
> —*Jeff F. June, 1973, Frankford, DE*

> *There's a Bible in there that can't be taken out. They say the closer you get to the door, the heavier it gets. No one used that old church for a long time. I guess they couldn't move the Bible so they just left it.*
> —*Frankie T. Aug. 1970, Snow Hill, MD*

> *Sitting on the altar there was an old Bible. It's written partially in Hebrew and partially in English. It's not chained or attached to the altar in any way, but it cannot be taken out of the church in any manner. Someone carrying it can get to a door or window, but no further. There is the feeling that something is pulling them back into the church. Supposedly several boys went to the church to remove the Bible, and when they got to the door there was a strong wind. Some of the windows broke, and the boy carrying the Bible fell through the floor and has never been found.*
> —*Iris K. Sept 1972, Lewes, DE*

> *The reason they can't get the Bible out is because after they pick up the Bible, they can see a fire outside the window surrounding the entire church. They always drop the Bible.*
> —*Sherry R. October 1970, Bridgeville, DE*

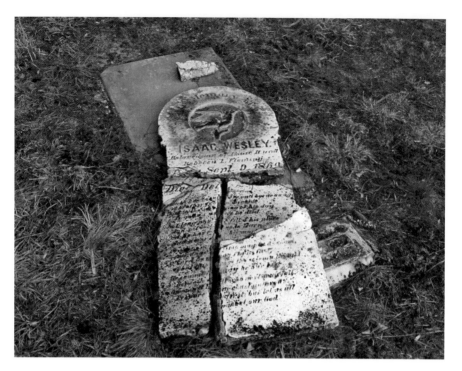

Broken grave marker in the Pusey Family Cemetery, former site of the Old Nazareth Church.

> *There is a church that has a Bible that appears at twelve o'clock midnight. If you enter the church at midnight, the Bible can only be taken as far as the door. It will then fade from your hands and disappear. When you look, it will be back on the podium. The Bible is only in the church at midnight!*
> *–Robert W. July 1971, Cambridge, MD*

Some of the references to the heavy Bible connect it with historic St. Martins Church of Showell in Worcester County on the opposite side of the Pocomoke River. This church, like the Old Nazareth Church, has its own haunted history. There are also references to churches in Delmar and Ocean View, Delaware, having a heavy Bible or a Bible with supernatural powers that kept people from removing it. It's likely that people in the area suspected something mystical or haunted about the vacant church ruin and graveyard, and the heavy Bible stories grew from there.

Eventually, the disused church building was donated to the Furnace Town Living Heritage Museum, which is just up the road. It has been beautifully restored and is part of their village of historic buildings. The Bible spell

has evidently been broken. You can see the Bible among artifacts displayed inside the museum. But the church—even in its new location at Furnace Town—is still apparently associated with haunted activity. Periodically, ghost hunts and paranormal investigations are held at night at Furnace Town. The Old Nazareth Church has shown significant supernatural activity in some of those investigations, which include clear electronic voice phenomena, photographs with anomalies and investigators feeling a physical touch. The old graveyard and lot where the church once stood is now noted on a sign by the road as the Pusey Family Cemetery, with the grave of Purnell Pusey—the man who granted the land for the church—marked by an obelisk in the near center of the lot, as well as many other tidy graves. Some go back to the mid-nineteenth century, and some have fallen down. The graves cover two opposite ends of the fenced-in rectangle, and there's an obvious vacancy where the church once stood. Just behind the fenced-in cemetery is the entrance to the Pusey Branch Nature Trail, a lovely forest walk.

> *Reader pass on and ne'er waste your time,*
> *On bad biography and bitter rhyme*
> *For what I am this cumb'rous clay insures,*
> *And what I was, is no affair of yours.*
>
> —epitaph of Mary Lefavour

THE OLD IRON FURNACE AND THE MAN WITH THE CAT

Deep in the Pocomoke Forest, along the banks of the Nassawango Creek just northwest of the town of Snow Hill, are the skeletal remains of an old iron furnace. In its day, it generated income for more than three hundred people—all of whom lived on the site in a company town built by the owners of the furnace. Ore was extracted from the boggy soil in the Pocomoke Forest and smelted in the iron furnace. Iron was shipped out by way of the Pocomoke River to cities in the Mid-Atlantic region. As the demand for iron grew, the company expanded, and workers lived on site in small homes. A village grew on the site with its own gristmill and sawmill, post office, store, woodworking shop, printer and church. Soon there were blacksmiths, cobblers, weavers, broom makers and even a small school in this "furnace town." Both slaves and free blacks were a part of the iron furnace workforce, and much of it was grueling work.

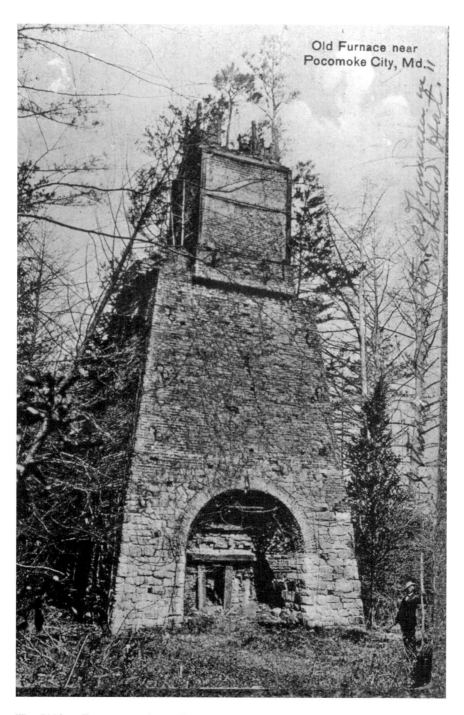

The Old Iron Furnace near Snow Hill. *Courtesy of the Edward H. Nabb Research Center.*

Spirits of Somerset, Wicomico and Worcester Counties

By 1850, the competition had become too much for the Nassawango iron furnace, and it closed down. The company went bankrupt. The workers all relocated, and the little village was abandoned. By 1929, all of the buildings had rotted away down to their foundations. In 1962, the property was donated to the Worcester County Historical Society, and it removed more than one hundred years of vegetative growth, cleared the site and stabilized the iron furnace. Eventually, Furnace Town was created as a living heritage museum where people can visit the site and have an authentic experience of what life was like when the furnace was in operation. Many historic buildings have been relocated to the grounds and restored, and artisan reenactors give live demonstrations of broom making, blacksmithing and other mid-nineteenth-century trades. Visitors can also walk right up to the top of the furnace and view the operation. This old relic and its surrounding makeshift village draw thousands of visitors to the Pocomoke Forest every year. It is the earliest surviving American furnace that employed the hot blast method.

But some believe that the ghosts of the old inhabitants are still there working the furnace, crafting brooms, preaching in the church and walking the grounds of the old forest village—just like they were doing 170 years ago, as noted by Pam M. from Washington, D.C., in October 1972: "There's an old furnace in the Pocomoke Forest all broken down and deserted. In October and November when there's a full moon—there has to be a full moon, you can go out there to this furnace and see this old man and a wagon drawn by horses. It's a little flat wagon with little sides, and he gets in and kinda just floats down the road in the wagon."

The most famous ghost of Furnace Town is that of an African American man named Sampson Harmon, who lived in the forest until he was 107 years old. He was born in 1790. Some say that he was born a slave and purchased his freedom, and others say that he was born a free man. Sampson Harmon actually stated that he was born a free man in an interview with the *Salisbury Advertiser*. He also expressed his anger about the way he was characterized in George Alfred Townsend's book, *The Entailed Hat*. Townsend never officially said that his character "Sampson Hat" (who worked at the iron furnace) was based on Sampson Harmon, but the similarities were overwhelming. The character in Townsend's book was arrogant and self-serving. And though the personality traits of Sampson Hat didn't align with Sampson Harmon, the physical characteristics did. Sampson Harmon was an amazing athlete, legendary for his ability to chase down a deer, catch rabbits with his bare hands and dive down into the river and catch a beaver. He never got cold, wore no coat in the winter and seldom wore shoes, but he always wore a hat. He

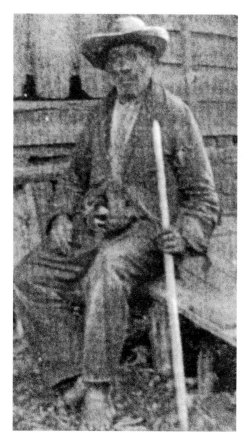

Sampson Harmon, who lived and worked at Furnace Town. *Courtesy of Worcester County Library, Snow Hill.*

came to live at the Nassawango village when he worked at the iron furnace. He was married several times and had fourteen children. He outlived them all.

When the furnace closed down around 1850 and everyone left, Sampson stayed on in his little shack. He continued to live there in the forest long after everyone had left with only cats as his companions. He planted a garden, hunted and, in his later years, received some food and supplies from friends who would come out and check on him. He loved his cats. One cat in particular—a black cat named Tom—was his favorite. In 1898, when Sam was 107, the Worcester County authorities came out to Sam's forest home and told him that he would have to leave his home behind and relocate to the County Almshouse. Sam begged them to let him stay, and when they made it clear that he was leaving, he begged to let him take Tom with him. They refused. Sampson Harmon died within a year at the almshouse. His last wish was to be buried in the forest near his home. That request was also denied.

People have been seeing apparitions of Sampson Harmon for decades. A tall black man with a ragged coat and a hat has been seen walking through the forest from time to time, usually at dusk or at night by the light of the moon. Paranormal investigators have seen what they believe to be a spectral image of Sampson. Electromagnetic field detectors have shown spikes when these apparitions of Sampson Harmon are seen. Temperatures fluctuate, and photo images appear with strange defects or anomalies.

The staff members at Furnace Town maintain a feral colony of cats. One of the cats, a gray cat, seems to have a connection with something unseen.

This cat seems to hear things the other cats don't hear. It answers a call from an invisible someone or something. Sometimes it appears to be following someone. Staff at Furnace Town and people in the forest claim to have heard Sampson Harmon calling his cats. And these experiences are recent, so the activity in the Pocomoke Forest near the iron furnace is strong even today.

The Warren Mansion

No commentary about the haunted Pocomoke Forest would be complete without including tales of the Warren Mansion. This massive, Spanish-style dwelling sits on the Old Furnace Road just west of Furnace Town. In 1920, an artist from Pennsylvania brought his young family to the Eastern Shore and built his dream house in the Pocomoke Forest. Today, that house is commonly referred to as the Warren Mansion. Frank Algernon Warren designed this grand home. His intent was to create something that blended into the forest landscape rather than detracted from it. The inspiration for architecture was Frank Lloyd Wright, but Frank Warren's grand house has a singular style that is not imitated anywhere else on the Shore—or in the world. It is his personal work of art. He named the house The Forest.

The house is covered with sand-colored concrete stucco and has two levels, with the walls supported by many buttresses. Some say that the buttresses resemble the large tree trunks of the bald cypress that grow in the Pocomoke Forest. Frank and his wife, Mary, had nine children and raised them in this house, and most of them became educators locally. Many Lower Eastern Shore locals recall being taught or have family who were taught by teachers from the Warren family.

In 1935, at the age of seventy, Frank Warren was killed when his vehicle collided with a train. His children inherited the house, and his unmarried daughters lived in the house well into their senior years. When these Warren spinster sisters occupied the house, a haunted legacy began. In the old stories of the Pocomoke Forest and its ghosts, the Warren Mansion is always included with speculation about what the spinster sisters did behind the concrete walls of the mansion.

Is the Warren Mansion haunted? Probably not, unless the spirits of Mr. and Mrs. Warren and their children are present because they were so spiritually connected to their home. But the folklore surrounding the house suggests more sinister behaviors. Mr. Warren was evidently a bit eccentric,

The Warren Mansion in the Pocomoke Forest.

as artists can be. According to accounts from those who knew him, he always wore a big hat and a bow tie and had a flamboyant style. He drove a school bus around the town (perhaps because he had nine children). The Warrens apparently never invited anyone into their amazing home, and people naturally wondered about the inside of the house because the outside was so uncharacteristic of any home on the Shore. Mr. Bill Laws, who lived in Snow Hill well into his nineties, described Mr. Warren in November 1971: "Old Mr. Warren was peculiar. The only time anyone besides family entered his house was when he threw a New Year's Eve party each year. He stirred the punch with his feet. Another funny story about him was that he drove a school bus during the day and used it as a chicken coop at night. That fellow, he was a weird old coot." Sidney B., in November 1970, had this to say: "Old Mr. Warren drove his own school bus—one of the first to drive a bus. He called his bus 'Chicken Coop.' He wore old dark-rimmed glasses with black chains hanging on the sides. They're kinda funny people."

There is an entire folder in the Nabb Center Folklore collection about the Warren Mansion and the Warren family. People who gave commentary stated things about the Warren sisters that ranged from witchcraft to dismembering their parents and burying them in different parts of the house. Many stories are repeated with slight variations, but one common story is that Mr. Warren told all of his children that he would disinherit them if they married, so most of them stayed single and lived in the house. As Sallie P. noted in October

1972: "Mr. Warren said in his will that nobody in his family should get married and if they did they would be cut off from any inheritance.... He also made them work to pay for their education. One of the girls would work a year so the other could get some education. And by education, he meant at least a Master's degree. And everybody was supposed to come home for the weekends no matter where they were."

Another repeated tale—probably the most commonly told—is that Mr. Warren requested that he be buried in the house and that his permanent resting place is under the dining room table. There are accounts of the Warrens having attack dogs guard the property and people going on the property who are never seen again. Here are some more reminiscences:

> *The old man was buried in Snow Hill with his old bulldog that was killed with him. They moved him to the house later on. I have heard that he was buried under the dining room table.*
> *–Sidney B. November 14, 1970, Snow Hill, MD*

> *Reports say that there is a moat around the house. Any trespassers are shot at. The house is protected by dogs and men with guns at night. Supposedly, wire is stretched across the lane thus barring the entrance to the mansion.*
> *–Patricia H. 1970, Salisbury, MD*

> *Maybe because they seemed strange, their house or all of their mean dogs, there were many stories told about them. I heard that they buried their father under the living room floor. Out of respect they still set a place for him at the dinner table.*
> *–Betty Sue P. 1972, Salisbury, MD*

> *I heard all kind of tales about the Warren house ever since I was in elementary school. Some people say that people have been buried in the walls. The people who live there are all old maid schoolteachers.*
> *–Peggy M. August 1971, Willards, MD*

> *People say that their mother and father are buried under the kitchen table and every mealtime places are set for these two deceased.*
> *–Philip W. September 1971, Princess Anne, MD*

It seems that the Warrens were a very close and private family. They didn't entertain in their home, and they didn't like prying eyes. It's likely that

because this small-town country community couldn't get the answers that they wanted about the seemingly mysterious Warren family, they made up stories. I have personally heard some of the older people in the community comment about being taught by one of the Warren sisters, and the memories they shared were compassionate and spoken with a fondness for the teacher.

In recent years, the third generation of Warrens has opened the home up occasionally for tours and displayed some of Frank A. Warren's artwork in a partnership with Salisbury University. So far, there are no new haunted tales. But when I was standing on the road in front of the house to take the photo, I had to admit to myself that the house, the land and the trees set against the backdrop of the Pocomoke Forest had a sense of mystery—as if the house itself was suspended in time—the past mingled with the present and future. It is a mystical place at a distance.

Urban Legends

There's nothing like some good old urban legends about severed heads, hitchhikers and ladies in white to get the conversation going around a campfire.

Morning mist over the forest.

Spirits of Somerset, Wicomico and Worcester Counties

There are scores of these stories set in Pocomoke Forest—all alleged to be true. In fact, there was even a research paper about the forest and its lore in the folklore collection at the Edward H. Nabb Center at Salisbury University. Here are some of the most intriguing tales of the forest.

The Boyfriend

A boy and a girl were in a car and ran out of gas. They heard something. The boy got out to look for a phone and told her not to turn around or get out of the car and to lock all the doors. He was gone for a long time, and she kept hearing noises on the roof of the car. She never turned around at all. She just lay on the seat. She fell asleep and finally woke up. It was morning. She remembered what had happened, so she sat up slowly and looked out the front windshield. Then she turned slowly toward the back window, and she saw her boyfriend's head sitting on the trunk. She screamed and got out. The sounds she heard that night were the fingernails of her boyfriend scraping the top of the car where somebody had hung him feet first in a tree. This story is told as the honest truth. It explains what can happen when someone runs out of gas in the Pocomoke Forest. (Told by Wayne M., Apirl 12, 1975.)

The Hook Man

A young man and a young lady were parking in the confines of the Pocomoke Forest. The radio was playing, and all of a sudden a special bulletin came on. It seems that an inmate at the Cambridge State Hospital had escaped. He was last seen headed for the Pocomoke Forest from the Salisbury area. He could be recognized as being about six feet tall, weighing 165 pounds, having jet-black hair and a beard that was also black. His right hand had been cut off, and in its place was a hook. His problem was that he killed people who disturbed the Pocomoke Forest. In about half an hour, the young lady broke away from the young man's embrace scared to death. She insisted that he take her right home because she had heard a noise. When the young man and the young lady got out of the car, they heard a clanging noise. They looked in the gutter beside the car, and there lay a hook. To this day, the crazy man with a hook for a hand has been seen many times, but he has never been caught. This is a story that is well known and believed by many people. Who am I to say that it is just a story? (Told by Charles C., April 10, 1975.)

The School Bus

There was a busload of students going to see the Old Furnace as a history class trip. The bus driver decided that it was quicker to use some of the back roads in the forest. The bus had some engine trouble while on one of the back roads. The driver got out to check and try to find the trouble. All of a sudden, there was a noise as if people were walking up and down on the top of the bus. Many of the students got curious. Nobody was scared. But then several horribly ugly faces appeared at several of the windows. These faces appeared as if out of nowhere. The teacher told everyone to close their windows if they were open. She tried to calm everyone down. Then she went to ask the driver if he was ready to go, but he was nowhere to be found. There was a skeleton beside the front of the bus. The teacher very hurriedly closed the hood of the bus and got in and drove it back to the school. To this day, the bus driver has never been found, although many people say that they have seen him. (Told by Charles C., April 14, 1975.)

Fire Ball

A guy from Westover was driving his car through the Pocomoke Forest to Snow Hill. He looked ahead and saw a very bright object. The closer he got, the brighter the object became until finally it was directly in front of him about thirty or thirty-five yards. He couldn't tell whether it was yellow or green. Since the object was blocking the road, he could get only twenty-five yards in front of it. Suddenly his car cut off, and he came to an abrupt stop directly in front of the object. Too frightened to do anything, he sat in the car and watched it. It looked like a big yellow box. After fifteen minutes passed, the object slowly drifted off into the woods. The man's car automatically started and finished its trip driving down the road. (Told by Harvey B., age twenty-five, 1970.)

Ball of Fire (Again)

In about 1921, Paul Walker was holding a revival back in the Pocomoke Forest out past West Post Office, at Pine Ridge. Several of the local women had been converted, and some of their husbands were unhappy about it. They got together to take guns and beat up the evangelist and burn the

church down. When they got to the church, the leader of the group got up to the front door. It was open but he couldn't get in. He was paralyzed. As the others tried to get in, a ball of fire descended on the roof. It split in two and went down the sides of the church, scaring them away. That's what the man said. (Told by Mr. P. Morris, college instructor at Salisbury University, age twenty-nine, October 29, 1970.)

Sleep on in thy beauty,
Thou sweet angel child,
By sorrow unblighted
By sin undefiled.

–epitaph on a child's grave, 1887

Pocomoke City

Pocomoke City started as a trading post on the Pocomoke River in the late seventeenth century. Its industry, culture and recreation have always revolved around that dark river, which takes its name from the Indian words for "black water." Both the river and the forest are woven into the identity of Pocomoke City. The people of Pocomoke tout their town as the "Friendliest Town on the Eastern Shore"—that it is, at least in my experience. The town, like most of the small towns on the Lower Shore, has few resources, and funds are scarce. But its citizens have pulled together to produce enough amenities to keep a visitor busy for a weekend. They installed the boardwalk that meanders through the Pocomoke Forest. They established a town-owned waterfront restaurant, restored an old theater, renovated a historic home that became the town museum, turned a swampy field into Cypress Park, built a Discovery Center that interprets the natural landscape and culture and fortified a river walk that runs on both sides of the drawbridge, complete with hookups for boats and license-free fishing. All of these amenities are in one city block. The town has an amazing ability to work together, raise funds and get things done.

But it also has its ghosts. With the most haunted forest in Maryland on one border and one of the most mysterious rivers on a second border, the town is bound to feel the overflow of mystical energy. And it does. Pocomoke Police officers have said that the old armory where they used to be housed is haunted. There are jail cells fitted out in the back. A dispatcher stated that they would hear things coming from the old jail

cells at night even though the cells were vacant. She described one evening when she and an officer heard a loud noise in the cells and the officer went to investigate. There was one camera focused on the area, and the dispatcher could watch what was happening as the officer took a look. She saw an orb of light come right at him. He couldn't see anything but said he felt a rush of cold air. There was nothing in the cell area to link to the noises they heard. Police officers who formerly worked for Pocomoke told guides from our ghost tour company that they hated to go in that building alone.

A building contractor commented to me in an interview that he and his wife were looking to buy a home in Pocomoke, and a beautiful historic home on Walnut Street came up for sale. This was the home of an old shipwright. He loved the house. It has finely carved wood trim with great attention to detail. When he brought his wife to see it, she couldn't get comfortable in the house. She felt uneasy. She said it was hard to breathe, and she couldn't wait to leave. They didn't buy the house. The owner later decided to do renovations, and the same construction contractor got called for the job. He said that they were tearing out the plaster walls and removing the lath. Behind the lath in the living room, they discovered a pair of old, cloth baby shoes perfectly placed on one of the horizontal pieces of the wooden framing around the fireplace. He said it was eerie. It seemed obvious that someone placed them there on purpose.

A few months after hearing that story, I was guiding the Pocomoke ghost walk. Since the house with the baby shoes was vacant, I decided to walk the group down there and tell that story. After I finished the story at the Littleton Clarke House, which is just a block away from this house, we started to move toward Walnut Street. A woman in the opposite direction saw our big group and approached us wanting to know what we were doing. She was very nice. I explained that we were a ghost tour, and she asked if she could join the tour. We welcomed her and moved on as a group toward the shipwright's house. I pulled everyone together and told the story about the potential buyers who declined and the hidden baby shoes. Then the nice lady who had just joined us said, "This is my house."

The coincidence stunned us all, but I told her I thought the house was vacant, and she explained that she had just bought it. She also said that she felt those spirits too, but they felt welcoming to her. Sometimes she'll come out when the tour is coming through, and she tells the guests about her house and how the spirits make themselves known. She is very happy there—with the spirits.

The historic homes, the streetscapes, the community garden and the friendly people must hold the spirits that want to stay connected to this friendly town.

THE MAR-VA THEATER

Most old theaters are haunted. Like jails, courthouses, battlefields and graveyards, places where there is high collective human emotion tend to have a thin veil between the two worlds. You can almost see the old soldiers walking, running and dying at the Gettysburg Battlefield. The energy of their deaths and suffering is almost palpable. The negative emotion of old jails gives off a fearful presence. And courthouses have an anxious energy, like hospitals. Nothing good (except a marriage) ever happens in a courthouse. It's a place of judgment and punishment. And if human emotion can imprint itself on an energy field, then it's no wonder that graveyards and cemeteries have a particular energy. They are repositories for emotion. We go to graveyards to be emotional—to mourn, to remember, to feel peaceful. Old theaters, like the Mar-Va Theater, have a high level of collective emotion because people come together and engage their imaginations collectively to appreciate an art form. The actors use their emotions to get into character and perform, and we, the audience, use ours to fire up our imaginations and live in the moments they create.

The Mar-Va Theater in Pocomoke City.

The theater was named Mar-Va because of its location on the border of Maryland (Mar) and Virginia (Va). It was built in 1927 as a vaudeville theater and eventually purchased by Dawson Clarke, who played the piano at the theater as the background for silent films. He was associated with it for a long time and also became mayor of Pocomoke. People in Pocomoke say that Dawson

Clarke used to black out the scenes he didn't think the kids should see at the movies. Others said sometimes he'd come up from behind and put his hands over a youngster's eyes when inappropriate parts of the film were projected. Another mayor, Curt Lippoldt, also had a strong connection to the theater. He was instrumental in its restoration and was a big supporter. Curt suffered a heart attack and collapsed on stage. He died a day after his eighty-fifth birthday.

Some people think that Curt Lippoldt and Dawson Clarke are the spirits that haunt the Mar-Va, as no one reported any kind of paranormal mischief prior to their deaths. Things will mysteriously go missing, and when assistance is called out to one of these men, items tend to show up quickly. The cleaning ladies are of the opinion that there are many spirits at the Mar-Va. One of them was cleaning the stage area when she brushed up against the stage curtain and it began to swallow her up. As she tried to break free, the curtain restricted her movement. She later stated that none of the cleaning crew would work in an area alone and that she won't enter the theater alone, nor will she enter without wearing her cross necklace.

Allie, a person who works in the theater, said that the toilets flush by themselves. They all have motion sensors as a flushing mechanism, and when no one is in the theater but the staff, the toilets will arbitrarily flush. She recounted an instance where she unlocked the door to come into the empty theater, and just after securing the door behind her, all the toilets in the restroom started flushing. Lights come on in unused parts of the theater, and on one occasion, she turned a light off, left the room and then saw that it had come on again. When she returned to the room, the light switch was in the off position, but the light was on. So she turned it on again and then off, and it finally went out. Allie shared another story about a time when she was alone in the theater before a show was about to start. She was popping popcorn in the concession stand. She heard a noise in the lobby and went out to see if someone had come into the theater. The doors were locked and no one was there. So she returned to the concession stand and closed the door. Then the knob started to rattle on its own. She said, "The fewer people we have in here, the more crazy stuff we get. Lord, help the one person who is here alone. We move about the theater in pairs now." Allie said the most disturbing thing happened when she was working a movie. Everyone was gone and Allie was locking up. All the doors had been locked. Then she heard a noise in the dressing rooms under the stage. She called out to see if someone was in there. No one answered. She heard it again and then investigated. She went into the dressing rooms and checked the bathrooms in there. She found nothing. Then, as she walked into the theater, she saw a

little girl standing there, just staring at her. She didn't respond to Allie; she just stared. Then she vanished.

Emily, who also works at the Mar-Va, said that the theater is full of spirits. She believes that there are many, not just the spirits of the mayors. Emily shared an incident when she was in the theater alone popping popcorn in the concession stand. She heard talking in the theater that sounded like a child's voice. She investigated and no one was there. She heard it again and checked the theater again but found no one. She went back to the concession stand one final time and then heard what sounded like a high-pitched scream. Terrified, she sprinted out of the theater.

Of all the 150 or so ghost stories I've collected about various sites on the Eastern Shore, there are very few where I have actually had an experience. The Mar-Va Theater is one of those places. Our twin granddaughters were participating in a summer theater camp at the Mar-Va a few years ago. At the end of the camp, they put on a little play. We got there early—in fact, we were the first ones to walk in when the doors opened. The box office wasn't due to open for another twenty minutes, so I chatted with my husband and daughter-in-law in the lobby while we waited. I had my back to the box office. I was facing my husband and leaning against a brass bar placed to help define a line for ticket buyers. I had a backpack with my camera in it slung over my arm. I distinctly felt someone walk behind me; in fact, my body was pushed against the brass bar and my backpack was shoved off my shoulder. I immediately turned around and said, "Oh, excuse me," but there was no one there. I could still feel the imprint on my shoulder of a person who had just brushed against me. I asked my husband, "Who just walked behind me?" He looked shocked. He said that he didn't see a person behind me, but he saw me move like I was being shoved. That is the only time I've ever felt a physical touch from the other side.

The Mar-Va has a great old energy and is such a gift to the community. Movies play on the weekend, and tickets are just five dollars. Popcorn is one dollar. You can't beat it for family entertainment. And the ghosts are a bonus.

Amarette and the Children of the Littleton Clarke House

About fourteen years ago, I met a couple in Snow Hill who shared a story with me about their stay at the Littleton Clarke House Bed-and-Breakfast in Pocomoke. We were talking about haunted inns in Snow Hill and they

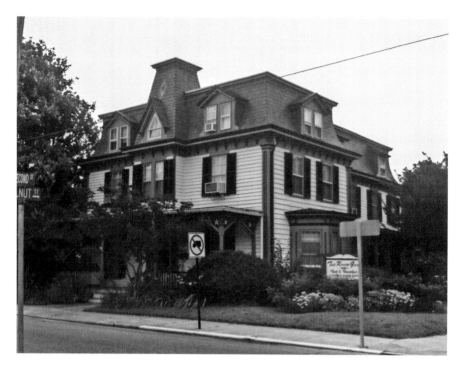

The Littleton Clarke House in Pocomoke City, now the River Gem B&B.

brought up their paranormal experience at this Pocomoke B&B. The woman said that she woke up in the middle of the night and saw a little girl standing by her bed. The child just stared, and the woman figured that the child lived in the house. She turned to wake her husband, and when she looked back for the little girl, the child was gone. The bedroom door never opened. Later that morning, her husband said that he felt something tugging at the sheets and thought a dog might be in the room trying to pull the covers off. He thought it was odd because the door was closed. At breakfast, they learned that the owners had neither a little girl nor a dog. They enjoyed their stay but never forgot about those strange moments. The owners of the Littleton Clarke House later became my friends, and I asked them about the incident. They said they didn't recall the couple and that the house was not haunted.

About ten years after that conversation, I started to write the Pocomoke Ghost Tour and decided to check in on the new owners of that B&B and ask them about the house. They actually had a story to share about something strange that happened shortly after they moved in. The owner is the mother of two young adult daughters. Shortly after moving in, the two daughters were in the living room, and they heard a heavy thumping upstairs. It

sounded like walking or footsteps. The older daughter went to investigate but couldn't find anything amiss. Everything was in order, and she couldn't find the source for the sound. This was disturbing because both of the girls clearly heard the footsteps. They shared this story with me in the same living room. The house is gorgeous inside and out, but it has a strong emotional presence—the kind that is magnetic and makes you want to go in and sit for a while. It's the same presence I felt when I visited the previous owners. This particular house is also on our Pocomoke Ghost Walk, and it happens to be a place where our guests get a lot of anomalies in their photos, more so than any other stop on the Pocomoke walk—except for the forest, of course.

Littleton Clarke built the house in about 1860, and it was one of the most ornate and expensive houses in the town. Clarke was part of the family who owned the town drugstore, and drugstores were a very good niche in the mid-nineteenth century. His wife, Amarette, was a successful milliner in town—so successful that she trained other milliners. The Clarkes moved into the house with two little children and one on the way. Littleton Jr. was three years old, and his brother, Ortho, was two. Julius, known as "Jukey," was born that same year. The family continued to grow. Evelyn was born two years after the move, and little Mary came in 1864. By the fourth year, the Clarkes were living in this big beautiful home on the corner of Second and Walnut Streets, they had five children and a thriving business. But then begins the saddest story you'll ever hear.

In 1865, little Mary died. There's no mention of how, but child mortality at that time was high. Less than two years after that, sickness struck the Clarke household. One by one, they died. Littleton Jr., then Ortho, then Evelyn and, finally, Littleton, Sr.—they all died in 1866. There is no cause of death indicated regarding the children. There is only the death year of 1866. Littleton Clarke Sr. is noted to have died from pneumonia. Only Amarette and Jukey survived. There was a court settlement involving the house, so evidently ownership and the financial security that went with ownership died with Littleton Sr. In 1868, the court awarded the home to Amarette, and she sold it the same day. Then history of her is silent except for a few unsubstantiated references of Amarette having to live above her millinery shop.

Jukey vanished. He doesn't appear on the census, and he is not listed on the tombstone with the dead children. In digging through many records, I finally found out what happened to him. Evidently, Amarette gave Jukey up shortly after the deaths of her family members. The rector at Pitts Creek Presbyterian Church took Jukey on as his ward. And Jukey moved away from Pocomoke. In 1871, Amarette married a ship captain from New York named

Henry DeKay. They had one son they named Henry Jr. He died when he was eight and was buried with Amarette's other children. The 1900 census shows a sixty-three-year-old Amarette living in a rented house in New Jersey with her husband of thirty years, Henry DeKay. His occupation is listed as manufacturer of handbags. It was interesting to see Amarette's census entry regarding children. Under the column entitled "Mother of how many children," Amarette reported eight. Under "Number of these children still living," she reported one. That would have surely been Jukey because he was still living in 1900. The number eight was clearly written. It didn't look like a six or any other number, so one must wonder if there were two others who died. If there were, they must have been born after the DeKays moved to New York and buried outside Pocomoke. Four years after that census was published, Amarette died and was buried in Pocomoke with her five dead children. A genealogy file online states that Henry DeKay died six years after Amarette in Pocomoke, so they must have come back in their last years.

One bright spark in this very sad story is Jukey (Edward Julius). The rector of Pitts Creek Presbyterian Church took Jukey into his family and sent him away to be educated. Jukey grew up to be the head of Washington College's English Department and later served as the superintendent of Kent County, Maryland Schools. He married but had no children. When it came time to retire, Jukey and his wife returned to Pocomoke. But at age sixty, he wasn't ready to stop working. He founded a newspaper known as the *Worcester Democrat* and ran it for more than thirty years. He died at ninety-three and is buried at St. Mary's Church graveyard in Pocomoke next to his wife.

Amarette and her five dead children and first husband are memorialized on a marker in Pitts Creek Cemetery near the present-day Winter Quarters golf course. In white marble framed in a crude brick structure, the memorial reads:

> *Here lieth all that is mortal of*
> *Littleton Thomas Clarke*
> *Died 1866, Aged 37*
> *His wife Amarette Jane Clarke*
> *(who married in 1870, Henry A. DeKay)*
> *Died 1904, Aged 68.*
> *Their Children*
> *Littleton Thomas Jr., Ortho Curtis, Evelyn and Mary Cornelia Clarke, Aged respectively 9, 8, 4 and 1½ yrs. Also Henry Morris DeKay Aged 8 yrs.*

Amarette never returned to the Littleton Clarke House after she sold it. The house was transferred to Benjamin Cator in July 1869 for an unheard-of sum of $3,000, and years later, the house went to Jeremiah T. Speights. In 1889, the property returned to the Clarke family when Marietta E. Clarke purchased the property; it remained in the family until the mid-twentieth century. Now it is beautifully renovated and operates as the River Gem Bed-and-Breakfast. But perhaps Amarette and her children do return every once in a while.

Snow Hill

Snow Hill is a haunted little town. As one of the most historically intact towns on the Eastern Shore, Snow Hill gives the visitor that feel of stepping back in time. It's the county seat for Worcester County and the oldest chartered community in the county. Chartered by the British in 1686, Snow Hill started as a trading post, and eventually that trading post grew to attain a Royal Port designation. While many Eastern Shore towns grew up around one industry such as shipbuilding or seafood distribution or agriculture products such as tobacco and produce, Snow Hill's economy was about the import/export trade, all operating from the Port of Snow Hill. Industries that grew were lumber, canneries, fertilizer and fine crafts such as cabinetry and textiles. Snow Hill is also the site of the first Presbyterian community in America. Francis Makemie came from County Donegal, Ireland, and founded his first community in a little building by the river. Eventually, that community built the beautiful church on Market Street. Francis Makemie went on to found three other communities in the area, and all of them are still active.

Snow Hill is home to the most publicized haunted property on the Eastern Shore: the Snow Hill Inn. That property has been featured in the *Baltimore Sun* (twice) and the *Washington Post* and many books on haunted Maryland and was even featured on a cable television series produced by National Geographic Television Network. The inn was formerly the house of Dr. John Aydelotte, who operated his medical practice from this home on Market Street. Dr. Aydelotte and his wife raised two children in that house, Mildred

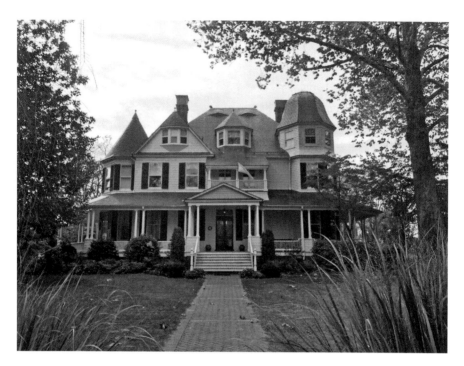

Snow Hill home of John Walter Smith, forty-fourth governor of Maryland.

and William. Mildred married Virginia state senator G. Walter Mapp and moved to Accomack County. William graduated from Washington College in Chestertown and then in 1904 went on to Pharmacology School in Baltimore, where he apparently ended his own life by "cutting his throat several times" according to the *Baltimore Sun*. William was twenty-one years old when he died. It seems young William wasn't doing well in school and didn't want to face his father's disappointment.

The *Baltimore Sun* stated that the landlady heard a noise upstairs. When she checked on William, he was on his bed bleeding to death. She called the authorities. In 1904, the coroner, paramedics and police investigator were all the same man. There were no forensic detectives or testing. Someone showed up, saw William on his bed, saw a knife under the bed and blood near a mirror and concluded that it was likely a suicide. As William's room was being cleaned out, they did find an unfinished note that read, "Dear Papa, it's useless to keep me at school." William's family never believed that he committed suicide, but in 1904, people didn't talk about such things. So whatever doubts or anguish the Aydelottes had over young William, they kept it to themselves. It wasn't until many years later that William's nephew,

G. Walter Mapp Jr., stated in an interview with the *Baltimore Sun*, "We never believed he killed himself."

So, is the unrestful spirit of William Aydelotte still haunting his old homestead? No one knows. The house has been largely vacant since the Snow Hill Inn officially closed about twelve years ago. The current owner is slowly renovating it. When the inn was operational, there was a very enthusiastic spirit that appeared in mirrors, opened and shut windows, locked people in rooms, shook their beds while they were sleeping and played with fire. The gas fireplace would light itself, as would candles and stoves. Construction workers were terrified to work in the house alone. When *National Geographic* sent investigators out to do paranormal research, they caught orbs flying like lasers on video film. I interviewed more than twenty people who gave testimony that the Snow Hill Inn was haunted. Perhaps it's William trying to get attention, or maybe it's some kind of poltergeist. Or perhaps the inn sits on some kind of vortex that is entryway into the eternal world for many spirits.

The Snow Hill Inn isn't the only property that's haunted. There are two other haunted inns, a haunted town hall, a haunted mansion and a haunted museum. And all of these ghostly sites are bordered by the Pocomoke River.

The Governor's Mansion

No man in Maryland, in the past generation, has exerted a greater influence on the state and its people than John Walter Smith.
–Tercentenary History of Maryland, *1925*

The maids quit when little Becky Cohen told them that there was a nice man in a rocking chair in her room. Becky further elaborated that the man said that he was happy to see a family with children move into his house. The incident happened shortly after Dr. and Mrs. Cohen moved their young family into the Governor's Mansion in Snow Hill. Becky conversed with a nice old man who told her that she and her family would be happy in that house—he was sure of it—and that the house needed a young family like hers. Then Becky mentioned her conversation to the maids.

Mrs. Cohen persuaded Becky to change her story, and the maids stayed on. But the Cohen family told that story over and over and stated that they always felt the presence of that man—a kind, gentle presence—for as long as they lived there.

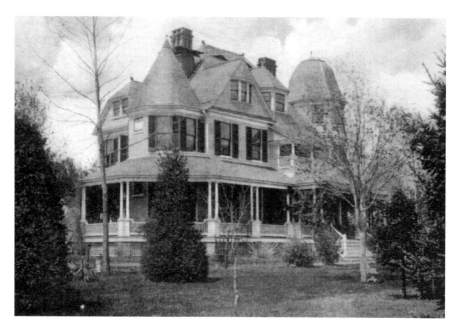

The home of John Walter Smith in Snow Hill. *Courtesy of the Edward H. Nabb Research Center.*

That house that the Cohens moved into was, and still is, the most elaborate house in Snow Hill. It is certainly one of the most elegant Victorian mansions on the Eastern Shore. It is known as the Governor's Mansion, built in 1889 by Maryland's forty-fourth governor, John Walter Smith. It sits on a little rise just at the crest of Church Street going out of town. When the house was completed, the property had ten thousand square feet of living space, two towers, a slate roof, a pool, a tennis court and a carriage house; it spanned a full city block. An iron fence with a gated entrance bordered the vast property when the governor lived there. During his tenure as Maryland's governor, John Walter Smith occupied the governor's residence in Annapolis only during the ninety-day legislative session. Once the session concluded, he returned to his mansion in Snow Hill and oversaw state business from there. He held meetings there, entertained dignitaries and gave public commentary from a tiny little town in Worcester County 110 miles from the state capital. It was during this time that the house became known as the Governor's Mansion, and the name stuck.

John Walter Smith was born in Snow Hill in 1845, and his thirty-two-year-old mother died in childbirth. By the time he was five, he had become the ward of Ephraim King Wilson—also of Snow Hill—who was a prominent leader in Maryland politics. John Walter was educated in public schools but never

went to college. He went to work in a store in Snow Hill, learned shrewd business practices and eventually built his own lumber business, co-founded the Bank of Snow Hill and became a wealthy landowner in Worcester County. He went on to be president of the Maryland Senate, a U.S. congressman and forty-fourth governor of Maryland, finishing his political career as a U.S. senator.

Much is written about this special governor, his commitment, his perseverance and his persuasiveness. "He never deserted a friend" was a common reference in the Maryland Senate. The *Tercentenary History* noted, "He did not get his results through oratory, eloquence or newspaper appeals, but through the force and charm of his personality, plus the exercise of an energy and spirit that grew stronger as obstacles piled higher, and never flagged until the end was achieved."

John Walter Smith. *Courtesy of the Edward H. Nabb Research Center.*

John Walter Smith and his wife, Mary Frances, had two daughters, Charlotte and Georgia. Charlotte died of tuberculosis when she was a child, and the pain of that loss was magnified by the treatment of tuberculosis patients at the time. TB patients were quarantined to the homes, and many medical professionals withheld care because they were frightened of contracting the disease. When he was governor, John Walter Smith became a devoted advocate for tuberculosis patients. According to a Baltimore medical journal, he sent a message to the General Assembly requesting that members enact legislation that would establish a commission to investigate "the prevalence, distribution and causes of human tuberculosis in the state of Maryland, then determine its relation to public welfare and devise ways and means for restricting and controlling said disease."

Governor Smith's continued efforts led to the establishment of the Maryland State Sanatorium on the top of Loop Mountain in Frederick

County, about sixty miles from Baltimore. It was the first facility of its kind in Maryland and paved the way for more thorough and compassionate treatment for tuberculosis patients. He was also instrumental in establishing the first state psychiatric hospital. And in addition to his noted efforts toward healthcare reform, he also pioneered the path to major education reforms, including free textbooks for all Maryland students.

After his term as governor was finished, John Walter Smith moved to Baltimore and stayed active in political life. He kept the Governor's Mansion as a summer retreat. When his wife passed away, he moved in with his widowed daughter, Georgie, and her two young sons. According to many of his friends, those boys (one named after him) became the light of his life. He died in 1925 at the age of eighty, and after his death, ownership of the mansion passed to Georgie. But the house sat vacant for many years and began to deteriorate. John O. Byrd, mayor of Snow Hill, purchased the property in 1940 and sold it five years later to Dr. Cohen, who operated a medical practice that he ran out of his home.

Mrs. Mabel Cohen (Dr. Cohen's wife) gave commentary in 1971 to a Salisbury University student who was taking a folklore class. She stated that she and her husband purchased the home in 1945 after it had been vacant for nearly forty years. One day shortly after moving into the house, her little daughter, Becky, woke up from her afternoon nap and saw John Walter Smith in her room. He told Becky that he was glad that she was going to live in his house, as no one had lived in it for a long time and it needed a family with children. After Becky told the maids about the governor's visit, the maids decided to flee, fearing the house was haunted. Mrs. Cohen convinced the maids that Becky had made the whole thing up, and the maids ended up staying.

In her commentary, Mrs. Cohen stated that she believed her daughter's story and believed that the spirit of the governor was present. But she convinced the maids that it wasn't true because she wasn't going to leave the house simply because it was haunted. The Cohens retold that story often, and it circulated around the community for years, keeping the memory of John Walter Smith alive.

Although the property has been subdivided since the governor lived there, with the carriage house being broken out as a separate parcel, the old glory of the mansion still shines through. The current owners have restored the house and the grounds to appear as they did when the mansion was built 120 years ago.

The sign in the front yard reading "The Governor's Mansion" is a silent tribute to the man who is lovingly remembered for his contributions to the state

of Maryland. It also reminds us that John Walter Smith, who was a wealthy state senator and U.S. congressman before he built the house, chose Church Street in Snow Hill to define his legacy. He loved his home and his hometown.

As previously mentioned, Governor Smith lost his young daughter Charlotte to tuberculosis and spent much of his political career advocating for TB patients and their families, shaping a future where they didn't have to wither away in a quarantined home. His leadership led to the establishment of Maryland's first state sanatorium for tuberculosis patients in Sabillasville, Frederick County.

It's an interesting coincidence that at age sixteen, Mrs. Cohen, a native of Hurlock, began nurse's training at that very same tuberculosis sanatorium. It was there that she met Dr. Paul Cohen. They were married in 1936 and moved to Salisbury, where Dr. Cohen was named superintendent of the Pine Bluff Tuberculosis Sanatorium. It was sheer luck that they stumbled onto the governor's house in Snow Hill. The town mayor, John O. Byrd, had purchased the home so that it wouldn't be lost to demolition by neglect. He held it for five years, looking for the right family to sell it to—a family who could restore it and bring it back to its former self, rising to that landmark status that it once had in the community. He approached the Cohens, suggesting that with a little love and investment, the mansion could become both a family home and a place where Dr. Cohen could set up a medical practice. The Cohens purchased the mansion, and when they moved in, the good governor was waiting for them. And according to Becky Cohen in the 1914 *Wicomico News*, he offered a warm welcome: "There is no man who has had such a wonderful era of office holding and political successes as this man from Worcester who has been able to stand upon the field of battle and see every foe vanquished and disappeared, and whose fortunes still stand out foremost and whose guiding star still leads him towards the goal of political successes and achievements."

THE SPIRITS AT THE RIVER HOUSE

Set along the Pocomoke River, just at the headwaters, is a sprawling Gothic Revival house with a large yard bordered by an iron fence. It's a house synonymous with the town of Snow Hill. Everyone who drives through town on Market Street sees it. It's an impressive home. It's also a home that's been known to be haunted—some say by children and others by a former owner.

The George Washington Purnell House in Snow Hill, now the River House Inn.

If human emotion can affect and change an energy field, leaving a remnant of those emotions behind, then this house would have strong mixes of sorrow and joy. Today, it's known as the River House Inn, and it has been operated as an upscale bed-and-breakfast for more than twenty years. But prior to that conversion from home to inn, it was the family home of George Washington Purnell and his descendants. The house was built in 1860 by a Snow Hill lawyer who later couldn't afford it. An investor bought the property, which included the little house next door, and he rented the little house to an aspiring Snow Hill attorney, George Washington Purnell.

George was from a prominent Worcester County family. He joined the Confederate army during the Civil War and, within two years, was serving as an officer in the Second Maryland Cavalry. He was captured and sent to a prison camp in Ohio. When he was released, he returned home to Snow Hill and began his studies to be a lawyer, and by 1877, he was starting his own family and had saved enough money to purchase the River House. He lived there until his death in 1899. He was fifty-eight, and most of his children had died young in that house. Two little boys, each named William, and a daughter named Margaret died under the age of six. Little George

Washington Purnell Jr. was born the year they moved into the house but died before his first birthday. All of his little children are buried in a line with small headstones at All Hallows graveyard on Market Street, where George and his wife also rest. George's descendants lived in the house until the 1970s, when the last Purnell, Frances Purnell Thebald, passed away. Frances was George's youngest child, so for nearly one hundred years, this house belonged to one family. And they seem to be hanging around.

When Larry and Suzanne Knudsen purchased the River House Inn in 1991, they had a May 1 deadline to open. The two parlors had yet to be wallpapered, so Suzanne hired workers immediately. She said that the existing wallpaper was put up in the 1890s. They knew the date of installation because the workers who installed it left pencil markings as a sort of artist's signature, which was uncovered when the old wallpaper was removed. In a high corner near the ceiling of each room, the paperhangers wrote, "Charles Bochner [written "Charles B." in one room] and Frank Russell. Artistic Paste Demolishers and Paint Slingers." Suzanne stated that near one of the signatures there was also a short commentary: "It took all day to paper this room and a little more." The paperhangers dated their work April and May 1890. The style of the old wallpaper was a heavy Victorian print in two patterns that covered both the walls and ceiling. At one hundred years old, the old paper was crumbling and had been mended with scotch tape that had faded to yellow over the years. It took the crew several days to strip and repaper one room.

Suzanne asked the crew to stay on for a few days to do the other parlor. One of workers stayed overnight in town so he could get an early start. He appeared on the porch at 8:30 a.m. ready for work. Suzanne and Larry were still in their bedroom, not yet having dressed for the day. At the time, the only piece of furniture on that first level was a small chair at the base of the stairway. Suzanne came to the top of the stairs when the worker rang the doorbell and told him that she'd be down in a minute to open the door. As she descended the stairs, she saw a roll of wallpaper sitting on that chair. It matched the 1891 wallpaper that was being removed from the parlor walls, and it looked brand new, without a wrinkle or any fading. Neither she nor Larry had ever seen it before, and they were the only two people who had been in the house since the workers left the previous day. How it got there is still a mystery. Years later, Susan asked the previous owners of the River House Inn if they had left it behind. Those owners not only said that they didn't leave it behind, but they also said that it couldn't have existed. They stated that they had scanned every inch of

that house for belongings needing to be packed before they left. It wasn't there when they were there.

When Suzanne started looking into the Purnell family genealogy, she noticed that there was a long gap in ages between George Washington Purnell's youngest child, Frances, and her next oldest sibling. That's when Suzanne took a look in the graveyard and found all of the Purnell graves—all of the little children lost by George and his wife, Margaret. Suzanne said that there weren't any more unexplained events during their twenty-year tenure as innkeepers, except for the occasional phantom smell of pork chops cooking. She figured Miss Frances Purnell was just trying to help out when they first moved in.

I interviewed the new innkeepers, who purchased the inn from the Knudsens, and they said that they knew of no ghosts, but their teenage niece who was living with them had an experience when they first moved in. With their permission, I interviewed the niece. She said that when they first moved in, her room was temporarily on the first floor. She was repeatedly awoken by the sound of little footsteps running up the stairs. They were quick and light, like the footsteps of a child or a small dog. This frightened her. There was also an account of a guest who paid in advance for a week's stay at the inn. She left in the middle of her first night, leaving a note behind that stated there were too many spirits there interrupting her sleep.

On a ghost walk in 2015, I stopped in front of the River House Inn and began to tell these stories. When we were finished, I led the group toward the river, but a child on the tour—a girl who was about three or four—wouldn't leave the spot where I was telling that story. The group stopped to wait for the child, but she clung to the iron fence. Her mother coaxed her to come along, and the child said clearly, "I don't want to leave. My friend is here." When her mother asked her, "What friend?," the little girl replied, "That friend," pointing to the fence. As we walked away, the little girl said, "My friend is dead."

Talk about your chilling end of a ghost tour. No one knows for sure who or what may be haunting the River House Inn. There are many guests who stay there year after year, and brides who get married on the grounds overlooking the river have felt the quiet benediction of that lovely old home—just as I'm sure George Washington Purnell did when he enjoyed that home and walked those grounds with his children.

HAUNTED FIREHOUSES

In my travels across the Eastern Shore, I've interviewed more than one hundred people about ghosts, hauntings and mystical experiences. Additionally, I've collected more than two hundred haunted stories. It's interesting to pull out common threads and patterns that appear. For example, all courthouses and jails seem to be haunted. You don't even have to ask. People who work in these places or have had to spend any time in them will volunteer to tell you all about the unexplained events, phantom footsteps, chains rattling, spectral figures walking the halls and weird anomalies on security cameras. If it's true that human emotion can change an energy field and, when magnified, can bore a hole in that which separates this world and the spirit world, then it makes sense that all jails and courthouses should be haunted. Nothing much good ever happens in these places. There's pain, ridicule, accusations, lies, prosecution, punishment and judgment. Except for the occasional wedding, it's safe to say that courthouses and jails have strong negative energy. And my files are full of ghost stories in these places.

But another interesting pattern in my ghost story collection is haunted firehouses. One usually expects a haunted building to be old and historical. The ghosts are from a long time ago. But nearly every town where I've had enough stories to craft a walking tour has a haunted story about the firehouse—some of those in firehouses that were built in the last thirty years. I began asking the guests why they thought this was so. Why would firehouses tend to be haunted? The responses differ a little, but most people

Firemen from Snow Hill standing behind the old firehouse, 1927. *Left to right, first row*: Andy Hauburt, Herman Adkins, Steve Purnell, Peter King Sturgis, Harry Bradford, William Price (glasses), Edward Wilson, Ed Deshields. *Left to right, second row*: H. Shockley, John Timmons, Straghn Sturgis, Jesse Goodman, Calvin Hayman, Sam Riley, unidentified, Walter "Hick" Williams and George Vincent. *Courtesy of the Town of Snow Hill.*

concur that firehouses are close to life and death—these men and women walk on that fine edge between the two worlds. They also develop a fraternal sense of belonging to one another. It's no wonder they want to return to that place of belonging.

Snow Hill Town Hall

The town hall in Snow Hill was built in 1893, shortly after a big fire that destroyed most of the downtown. A fire truck was parked on the first level, and people affiliated with the fire company used the back entrance. Town offices were on the second floor. At one time, it served as a police station and a reporting station for World War II signups. The Snow Hill Volunteer Fire

The Snow Hill Municipal Building served as the firehouse. It's now the town hall. *Courtesy of the Julia A. Purnell Museum.*

Department was established in 1897 with twenty-eight founding members. Every fire company in Maryland was assigned a number. Snow Hill was assigned 400. Today, the building looks much the same, except that two windows have replaced the garage-style door that was used by the fire truck. Today, the building serves as the Snow Hill Town Hall, and the staff there has talked about unexplained phenomena that began to occur shortly after an interior renovation started a few years ago.

The only office at the time that was permanently occupied on the second floor was the town manager's office, located toward the back of the building. Full-time staff on the first floor would hear activity in the unoccupied rooms on the second floor during business hours. They heard the sound of drawers opening and closing, desk chairs moving across the floor and an occasional voice. The town manager (when upstairs in her office) said that she didn't hear these things. One other strange thing happened. The phone lines are all linked in one system. If a person is on the phone, that particular line will show that it's being used on all the phones in the system. The front office on the second floor was the one that was most active. Staff on the

first floor would hear a kind of white noise or static coming from upstairs. They'd investigate and find that the static was coming from the speaker on the phone. And the phone line was open but not connected to any call. This is the same as leaving the phone off the hook, but the alarm noise that usually sounds when the phone is left off the hook never went off. That static sound from that phone happened on more than one occasion. Other office workers said that they felt like they were being watched when they walked up the steps. Convinced that there was a spirit in the office, some of the staff decided to have a séance and ask the spirit to communicate with them. One of them asked the spirit if it was a man or a woman, and they got a response—one they'll never forget. Immediately after asking, they heard a loud, soulful groan coming from upstairs. They said it sounded like a person in terrible agony. The paranormal activity lessened once the renovations stopped, but there are still occasional indications that the spirits are active.

The Cook at the Princess Anne Firehouse

The Princess Anne Firehouse isn't an old building, and I would have never suspected that it was haunted. The fire chief saw our tour walking past the building and pulled us aside to tell us about the goings-on inside the firehouse. He said he comes in by himself during the day from time to time, and he'll hear movement on the second floor. When he investigates to see what's up there, no one is in the building. He said it happens often. A volunteer fireman said that they've seen an African American woman in there in the middle of the night. This fireman said they'd be asleep, wake up to the noise and look through the dark and notice a shadow of a person walking up the stairs. Of course, when they investigate, there is no one there. Another fireman who saw the same shadow of the black lady said that it's probably the spirit of a woman who used to always bring them food. She was a cook at the Washington Hotel, and she'd often bring food over for the firemen, or she brought food for events that happened on the second floor. Recently, they did some renovations on the second floor and installed some nice bunks where the volunteers could sleep. During the renovations, they removed an old framed portrait of a previous captain of the fire department. It was left leaning up against a radiator. In the middle of the night, the firemen in those bunks were awakened by the sound of that portrait falling over and the sound of shattered glass. When they got up and saw the portrait face down,

they picked it up but noticed that there was no shattered glass. They replaced it again, securely leaning it against the radiator, and went back to bed. One hour later, it fell over again and woke them up. One of the firemen got a nail and hung the portrait, and the rest of them went downstairs to sleep. Some of them say that they still won't sleep up there. The Princess Anne Firehouse had so much paranormal activity that they called in investigators to do a full-blown investigation.

Old "Rock" at the Salisbury Firehouse Headquarters

Another famous firehouse ghost is Marion Slemmons "Rock" Taylor of the Headquarters Firehouse in Salisbury. The Rock Taylor story is widely circulated, and lots of people can tell you that "old Rock" is still hanging around headquarters. But few can tell you who this man was. Rock was a painter by trade, but he began his service as a volunteer fireman in Salisbury in 1919 when he was thirty-five years old. He was made chief in 1934 and retired twenty years after that at age seventy. After his wife, Agnes, died in 1936, Rock moved into the firehouse and lived there until he died in 1967, thirteen years after his retirement. He was known as "Rock" and as "Pappy" and was sometimes referred to as the "Whistling Rock"—a nickname he gained because he always started the morning with a whistle.

The presence of this beloved member of the Salisbury Fire Department was still felt with various unexplained events and occurrences. One firefighter recalled that the televisions would turn on when no one was in the room to watch. Air-conditioner window units would turn themselves on, and people would hear tapping noises on the window. The standard explanation was, "It's just old Rock." Some firemen claim to have seen a full-blown apparition of Rock walking the halls of the second floor. One story that I heard more than once was that the second floor was off limits to anyone but officers. When noises were heard on that floor—noises that sounded like someone playing pool—the fire chief came out to scold the firemen, asking who was on that second floor. When he investigated, there was no one on the second floor, but the pool table balls were still in motion. A few contractors who have worked on the building have experienced some weird things. Rock turns lights on and opens the window in the bell tower. Security cameras have picked up scenes where office chairs move on their own.

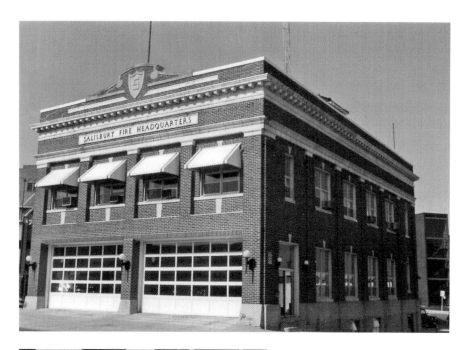

Above: The old firehouse headquarters in Salisbury. *Courtesy of the Edward H. Nabb Research Center.*

Left: Slemmons "Rock" Taylor of the Salisbury Fire Department. *Courtesy of Assistant Chief Bryan Records, Salisbury Fire Department.*

Spirits of Somerset, Wicomico and Worcester Counties

In a Salisbury Fire Department newsletter in 2015, the fire chief paid tribute to Rock and told about his accomplishments and commitment to the community. The chief didn't believe the Rock hauntings had a lot of credibility. He stated that with the style of the building, those phantom noises and door closures and rolling pool table balls could have been caused by the wind.

Today, the old fire headquarters building is an entertainment venue called Headquarters Live. There is live entertainment, a great bar and a good atmosphere for people to come together. I was recently there at an event and had the opportunity to talk to two of the bartenders. I asked them about the building and the renovations they'd done. Then I asked them if they knew anything about "Rock." They both were silent. It was an uncomfortable silence. So I asked again, and one of them said, "Well…he's here." They didn't tell me much about how they came to that conclusion, but it might be worth the price of a beer to find out.

WICOMICO SPIRITS

The solemn pines, in their stately way,
Gather the flush of the dying day,
And hold it a moment, still and warm,
Despite the wrath of the mutt'ring storm,
Whose flying couriers, through the air,
Leap from the gloom of their unseen lair
To herald the coming fray.
—*"A Summer Storm," by Amanda Elizabeth Dennis, born in Wicomico County*

Wicomico County is the center of the Delmarva Peninsula both physically and metaphorically. The Mason-Dixon line and the Transpeninsular Line—both historic land survey lines—cross in Wicomico County, defining the central point of the peninsula. This is how Wicomico earned its nickname as the "Crossroads of Delmarva." The county also has a national coast-to-coast highway (Route 50) running through it, which intersects with a five-hundred-mile U.S. highway that runs north and south, making Wicomico easily accessible from many population centers. Salisbury, its capital city, is the hub for commerce on the Delmarva Peninsula. Salisbury has the second-busiest port in Maryland; it has all of the major shopping outlets, including a large shopping mall. Salisbury is home to the peninsula's one big movie theater complex, the major hospital, the television stations, a nationally top-ranking university, a community college, a minor-league baseball team (with a stadium), a civic center, a massive city park with river walk, an award-

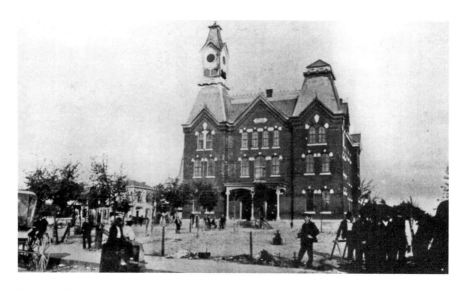

The old Wicomico County Courthouse. *Courtesy of the Edward H. Nabb Research Center.*

winning zoo and the only airport on the peninsula that has a commercial passenger airline. The closest areas with similar amenities would be Baltimore, Philadelphia or Norfolk. Wicomico County was carved out of Somerset County in 1867 and named after the Wicomico River, which flows through it on its way to the Chesapeake Bay. The name Wicomico is believed to be an Algonquian word meaning "where houses are built"—an Indian reference to development. Wicomico County was evidently a population center even before the colonists arrived.

Poplar Hill Mansion

In the center of the Salisbury historic district, at the end of Poplar Hill Avenue, there is an early nineteenth-century house that once sat on a farm owned by Salisbury's first surgeon, Dr. John Huston. It was named Poplar Hill because it does sit on a slight rise, and the drive leading to the house (now Poplar Hill Avenue) was once lined with poplar trees. It's the oldest documented structure in the City of Salisbury sitting in the oldest Salisbury neighborhood. Dr. Huston and his wife, Sara, had four daughters: Elizabeth, Isabella, Anne and Sally. Elizabeth and Isabella Streets in Salisbury were named for these Huston daughters, and at one time, there was an Anne

Spirits of Somerset, Wicomico and Worcester Counties

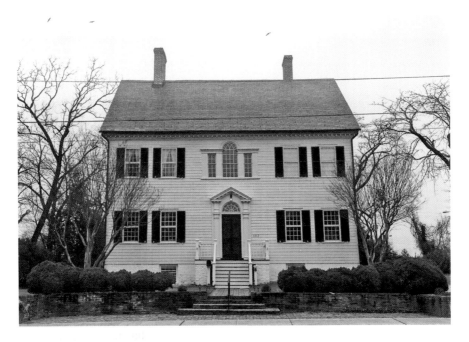

Poplar Hill Mansion in Salisbury.

Street behind the house. At one time, the family held eighteen enslaved African Americans, some of whose spirits are still around today.

Poplar Hill Mansion has some well-known ghosts that are documented in books, folklore collections and various Internet sites, including videos on YouTube of paranormal investigations. The most common haunted story told about the mansion is the sound of sweeping, especially on the stairs. According to Aleta Davis, chairman of Friends of Poplar Hill Mansion, many of the docents, volunteers and the curator have heard this sweeping from time to time. Aleta said that the sound often ascends or descends the stairs.

People have also seen apparitions of a Poplar Hill slave woman named Sarah. She was the nineteen-year-old caretaker of the Huston children who died in their nursery. A coal from the fire ignited her dress, and she couldn't extinguish it. She was burned to death. According to the Poplar Hill patrons, the wood floor in that room still shows the scorch marks from the fire. Child spirits are believed to also haunt that room. Little toys that are on display in the room are sometimes rearranged in the night, and a tiny rocking chair is sometimes turned to face the wall. There are also apparitions of a slave woman peering out the dining room window.

Several psychic mediums have visited the mansion and named some of the spirits that they've seen. Volunteers talk about a sonic boom that they hear outside the dining room window—a sound that they believe might be a message from the spirit world, a kind of warning to watch out for something or beware of something that is coming. One psychic medium told the former live-in curator that there was a male spirit present who mentioned the curator's recent fall down the stairs at Poplar Hill. The male spirit mentioned that he was the one who stopped the curator's fall midway down the staircase. The curator admitted that her fall had been broken by something that pinned her to the banister. The spirit also mentioned that the curator was wearing slippers. The curator denied this, stating that she was wearing flip-flops, but the medium pointed out that a nineteenth-century man wouldn't know what flip-flops were.

In addition to all of these mentions of encounters with spirits at Poplar Hill Mansion, paranormal investigators have gathered numerous electromagnetic voice prints with EVP meters—one being a very clear sound of a child saying, "Mom, I'm here." And visitors to the mansion have remarked how they will hit cold spots in various places—particularly in the small dining room where Dr. Huston had his surgery. A docent mentioned that when the mansion acquired a fortepiano, which is an earlier version of a piano, once a pianist sat down to play it, a rush of cold air went right through her. She described it as being like an ice cube going in one side of her body and coming out the other. The current curator, chairman and patrons all agree that Poplar Hill Mansion has wonderful spirit energy. There is nothing threatening or particularly scary. It is simply rich with the presence of the past.

THE CRIES AT HOLLOWAY HALL

The old building with the bell tower on the grounds of Salisbury University has been a town landmark for nearly one hundred years. Some say that both the bell tower and Holloway Hall—the building that supports the bell tower—are haunted with mischievous spirits that like to slam doors, confiscate tools and frighten whoever happens to be present when most people are gone. It's all in fun, of course, as students, maintenance people and cleaning crews have been commenting about this spirit's antics for years.

Holloway Hall was the first building on the campus grounds when the Maryland State Normal School was established in 1925, and it was the only

Spirits of Somerset, Wicomico and Worcester Counties

Postcard view of Holloway Hall at Salisbury University. *Courtesy of the Edward H. Nabb Research Center.*

building until 1950. A Normal School was a two-year school that trained elementary school teachers. It was established in Salisbury as the answer to a pressing need for schoolteachers in rural Maryland districts, particularly on the Eastern Shore. It opened with about one hundred students the first year. The building contained classrooms, dormitories, faculty offices, an auditorium, a dining hall and a gym. The building was named for Dr. William J. Holloway, who was the college's first president. Dr. Holloway was instrumental in getting the Normal School established in Salisbury. He served as the Wicomico County superintendent of schools, the state supervisor of rural schools and, finally, the assistant state superintendent. Then he was appointed as the president at the Salisbury School. In 1935, the school moved to being a four-year college, and today Salisbury University has forty-two undergraduate and fourteen graduate degree programs. It currently ranks in the top 15 percent of four-year colleges in the nation, according to the *Princeton Review* (2016 edition), and has more than eight thousand enrolled students.

But there are stories about strange things that happen around the old building with the bell tower. These stories are shared in the folklore collection in the Nabb Research Center, and they are freely shared around campus. The cleaning and maintenance crews have great stories to tell. Almost all of the stories begin with the sense of heaviness one feels when alone in

Holloway Hall. There is a keen sense of being watched or not being alone. Fire doors slam shut, the elevator goes up and down at will with no one riding it and lights come on in the middle of the night in rooms that are vacant. One cleaning woman shared that she saw a chair slide right out of the Social Room well after the room was closed for the night. A former maintenance person said that when he was working after hours and the building was empty, he thought he heard people talking in one of the rooms. He couldn't make out what they were saying, and he was surprised that people were even in the building at that hour. He went to check it out, and as he opened the door to the room, the talking stopped. He closed the door and began to walk away, and it started again. He repeated the process several times and then gave up and left.

Another maintenance worker said that things really started to happen during a remodeling. He was on the third floor and noticed a girl standing at the end of the hallway watching him. The area had been closed off to students, so he was about to tell her the area was closed when she vanished. He bent down to pick up a tool, and all of a sudden she was right in front of him, staring at him. He left without his tools.

The school newspaper has run stories about hauntings on campus, with most of them focused on Holloway Hall. What's the source? No one has any answers. A common story focuses on a female student screaming. Sometimes the story associates the screaming with falling. Some say the fall and screaming come from the bell tower, but most of the stories name the Great Hall in Holloway Hall as the location. Some of the screaming stories are linked to a student suicide, but the story is always set in the early morning hours. A Salisbury graduate relayed to me the stories he remembered hearing from other students:

> *The Great Room is adjacent to the Social Room. It's bigger with cherry paneling, and it used to be the cafeteria when the school was all one building. The Great Room has a "catwalk" gallery on the second floor. The girls' dorms were in the right wing second and third floor. One girl committed suicide by rushing down the second floor hallway and pitching herself over the railing onto the tiled floor below.*
>
> *At the same time at night, girls would swear they heard a scream, sort of accelerating, and going down the hallway toward the cafeteria. It was always the same time of night, same time as the suicide, according to the story. Later, renovations and expansions took place, the dorm rooms became faculty offices for the history department, and faculty staying late at night in their offices heard the same thing.*

In doing research, I found no record of any student committing suicide. I did find an article about a student's accidental death, but that was about a young man, not a woman, and the stories in the Nabb Center Folklore collection regarding Holloway Hall predate this young man's death. While this story is told and retold with various twists, the activity is still going on, according to the maintenance and cleaning people I interviewed. But the sources of the screaming girl and the mischievous door slamming, elevator riding and conversationalists who like to push chairs around remain a mystery.

The Witches Tree

Along the Swamp Road between Gumboro and Selbyville, Delaware and Whaleyville, Maryland, there is a lone tree. It's a mature tree that looks to be about 150 years old. The tree is associated with tales of witches being hanged, slaves being hanged, swamp monsters and demonic energy. It's known as the "Witches Tree." According to Ron Haas of Delaware Wild Lands, the tree is a swamp chestnut.

The tree is in Maryland at the edge of the Burnt Swamp, which is a large tract of swampland in Delaware that burned for eight months in 1930 due to an explosion from a still. Making moonshine in the swamps and forests was common practice on the Shore during Prohibition. The year 1930 was the driest in sixty years for Delaware, and it also had the highest temperatures in recorded history. The combination of high temperatures, drought and an explosion ignited a fire that burned not only the surface of the swamp area but also burned down into the dried layers of peat and became an underground fire that spread and popped up in farm fields and forests all around the region.

This amazing tree does stun the onlooker once it comes into view. It is set along a ditch that follows a dirt road flanked by rows of young trees. The dirt road is straight, flat and narrow (barely enough room for one car to pass another). There are no houses or any kind of structures along the road. The trunk of the tree is rooted in the ditch, so the tree literally grows from a trunk that is rooted sideways. This wouldn't be odd except for the massive size of the trunk. Because of this sideways rooting, the tree leans heavily toward the road. The trunk is strange. It has large bumps that push out and almost look like they might have started as branches but never developed. The tree branches were cut, but then they grew out again from those cuts so

The Witches Tree on Swamp Road in Whaleyville.

the branches have these strange collars on them. All of the timber lining the road is young. This is the only mature tree present. It looks like the timber was harvested, but this tree was left behind. According to a local, the trees lining the road are about fifty years old. So why did they leave this tree?

There is so much surface lore about this tree—that is, sensational references with no connection to any verifiable truth—that it's difficult to tell if there's any truth to the haunting or paranormal phenomena. I posted a picture of the tree on Facebook asking people to tell the stories they'd heard about this particular tree, and within a few days, the picture had been shared nearly four hundred times and there were more than one hundred comments. About one-fourth of the comments were from people who lived near the tree, knew it well and said there was nothing abnormal about the tree—no witches, no hangings of witches, no swamp monster and so on. Many said they had digital images of glowing lights and orbs around the tree or could personally feel an overwhelming sense of bad energy when near it. Some warned about wild dogs in the area and bad luck if you touched the tree. More than one stated that they had seen an apparition of an old pickup truck sitting behind the tree where there is no road access. There was a popular story about the Selbyville Swamp Monster, a kind of Bigfoot character that ran through the woods with a club. Some people photographed it. This was

disproved when a man admitted to jumping out of the woods wielding a club while wearing a Halloween mask and raccoon-tail hat. The swamp monster was a hoax. The majority of the Facebook comments were posted by young people who went to the tree at night, drank a lot and tried to scare themselves. The Witches Tree has morphed into an urban legend much like the Lady in White, the Hitchhiker, Bigfoot, cars that won't start and shadows of hangmen's nooses or hanging bodies. These are all the same stories told over and over at haunted sites around the world.

But most of these sites attached to urban legends have a source—an initial story that got it all going. It was difficult to even start a search for the source of the Witches Tree legend because there really was no official story. One possibility is that this tree was a "witness tree." This also was pointed out in the writings about the tree done by Dr. Carol Polio, an environmentalist with the National Park Service. A witness tree was a marker that might have designated a land boundary where a normal marker couldn't be placed because the boundary was inaccessible—like in a swamp. Land surveyors recognized witness trees as markers in these cases. A witness tree could also mark a memorable occurrence such as a treaty signing or a battle. This theory makes some sense. What makes more sense is that the word *witches* has a similar sound to *witness*, and perhaps the name reference to the tree was morphed from one word into the other over time.

The term *witches* in the eighteenth and nineteenth centuries on the Eastern Shore did not carry the same threatening label that it carried in Puritan New England. There were women who were called witches by the locals on the Shore, but they weren't executed, and in many cases, they weren't even harassed. They kept to themselves and served a purpose. The casual term "witch" was often given to Eastern Shore women who lived in remote sections of the community and practiced ritual healing. They were highly skilled in the healing arts, using natural medicines such as plants and herbs. Many of them were also in tune with energy movement similar to what Reiki healers do today as an alternative medicine healing practice. These women were rarely talked about because what they practiced contradicted local Christian beliefs. But they were also well protected and provided for by the community because natural medicine often worked, and if your baby had a bad cough and the doctor was far away or unaffordable, most parents would employ the skills of the local healer to save their child. But they wouldn't discuss it in the community. Illness was a scary thing. Even today, in the remote areas like lower Dorchester and Somerset Counties, people will admit that there were witches in the community as recently as

fifty or sixty years ago, but the conversations about these witches are short and often tense. One lower Dorchester man wouldn't talk about it on the phone and insisted I drive to Hooper's Island to talk about it in person. I did, and our entire face-to-face conversation lasted about three minutes. What he said was similar to what I'd heard from others. So perhaps this tree was associated with one of those healers who might have lived nearby or used a tree as a marker for a meeting place.

The Witches Tree definitely has a strong energy about it. When it first comes into view, it is stunning, almost frightening. It's such a strange-looking tree, unique in its environment. The first time I went to see it, I wondered why it hadn't been cut like the rest of the forest. Why would you leave a huge tree that's growing out of a ditch and is apparently near its end anyway? So I asked my forestry friends. They explained that harvesting a large tree that is growing on a river or stream bank defies good land management principles. A large tree's root system holds the soil in place, reducing sediment. I wondered why it grew in such a strange way with collaring on the branches and so much gnarling on the trunk. My arborist friends answered that question. When the branches were cut back—likely because they threatened to block the road—the shortened stubs can't receive enough light to be an energy source for the tree, so the tree pushed out these collars to compartmentalize and wall off decay from entering into the main trunk and vascular system of the tree. The collars are a self-protection mechanism.

Even with the scientific answers in hand, I was struck by the shape of the trunk. It looks like a human face—in fact, it has many human faces all over it. The setting is isolated, with almost no sign of any human life around. While I was photographing the tree, a pickup truck came down the old dirt road. An older man was driving it. He stopped and I said hello. He asked me if I'd come to see the tree and I said yes, but then I asked him what he knew about the tree. He said nothing. I thought maybe he didn't hear me so I repeated, "Do you know anything about this tree?" He stared at me for about three seconds and then said, "It's old." Then he left. I don't consider that a haunted encounter. I consider that an encounter with someone who didn't want to talk about that tree.

The next time I visited the tree, I brought my dowsing rods. Using these L-shaped rods can help detect underground channels of energy often referred to as ley lines. Many believe that when a tree grows on a ley line, the energy helps the tree to survive longer than others in its species and to resist disease and thrive—absorbing that constant energy flow. I was curious to see if I could detect a ley line; in fact, I expected to detect one. The first step in

dowsing is to focus and concentrate. Then, as you move forward holding the short end of the "L" in your hand and extending the long end perpendicular to your body, the rods will cross when you move over a ley line. I stood in line with the tree and positioned my rods. When I started to concentrate, I lost my balance. That startled me. So I tried again, and again I lost my balance. I couldn't stand without feeling like I was falling. So I moved away from the tree about ten feet up the road and tried again to concentrate. I was fine, but as I moved toward where I would pass the tree, I got wobbly. This has never happened to me before. I've had the rods swing and do strange things, but never have I had a personal sensation of imbalance. So perhaps there is some weird energy about the Witches Tree.

I believe the old wise people who have said since pre-Christian times that trees and stones can absorb the energy around them. Some believe that they can hold the memories of a place. And maybe this old tree has absorbed some of the negative energy imparted by young people who want to prove themselves more powerful than whatever allegedly haunts the tree—young people who have defaced the tree, spray-painted graffiti on it and left their trash behind. Perhaps the negative energy doesn't come from the tree but rather from those who visit it. I felt nothing negative. I didn't want to leave it.

In response to my Facebook post, I received a private message from a man named Jon H. who lives in Whaleyville near the tree:

> *Hello. I'm writing about your post on "the witches tree." I've lived my entire life in Whaleyville a few miles from the tree. The swamp road and my road are travelled nightly by people partying and drinking. I love where I live, my mother has hundreds of pics of the tree and other locations in the swamp, and more attention and people are not what they need. People vandalize the tree, tear up the road and endanger my life along with the 8 generations of my family raised here. I like the stories you tell but people use this location to party and do things they wouldn't do on a downtown ghost tour. I'm not asking for anything besides your awareness that this isn't just some cool place to visit, drunk late at night looking for ghosts, as some post describe, it's not in the middle of nowhere, it's my home and I like to protect it along with the ones I love. I thank you for your time.*

I was moved by his response and thought it was worth printing here. It's something all of us who are interested in visiting mystical or haunted sites should consider. Respect for these old sites is so important. That same man followed up with another note stating that the tree has only been called the

"Witches Tree" for the last twenty years or so, dubbed by kids looking for a good story. He ended that note with this statement:

> *The tree never hung witches, more likely a swing, in someone's front yard with the kids playing, at a time when there was no ditch and people a plenty coursed through the swamp, not apparitions. There are things in the swamp that are beyond my explanation, which bear upon the supernatural. But that tree is just a beautiful tree, kept standing by strength and deep roots. It will be a sad day when it goes.*

Old Princess Anne and Teackle Mansion

The Town of Princess Anne was established in 1733 and grew up around the Manokin River, where shipping and trade became prevalent. The town is known for its historic houses and churches, but the flagship building of the town, and probably for all of Somerset County, is the Teackle Mansion. There is nothing on the Eastern Shore quite like the Teackle Mansion. This brick mansion built to look like a Scottish manor house sits squarely on the edge of the town, inside the historic neighborhood. It is run by nonprofits that have successfully raised enough money to keep the mansion historically intact and allow it to be open to visitors. It is a remarkable treasure. And it's haunted.

Littleton Dennis Teackle, a wealthy lumber trader who also was well connected in Maryland's political circles, purchased the land in 1802 and began to build his dream house. The house took nearly twenty years to build, and Teackle almost lost it twice during the building. He built the house in proximity to the river (the Manokin River actually came up relatively close to the house in those days). The house had a grassy front lawn with a lane extending from the front door all the way to the end of the block. This only magnified the grandeur of this amazing mansion. This is the type of house the British aristocracy built after they stopped building castles. The wide lawn would have extended all the way to the first street corners, where gatehouses were built on each corner. An iron fence with double gates would have run across William Street, and no buildings would have been between the mansion and the gatehouses in the early nineteenth century. Mr. Teackle

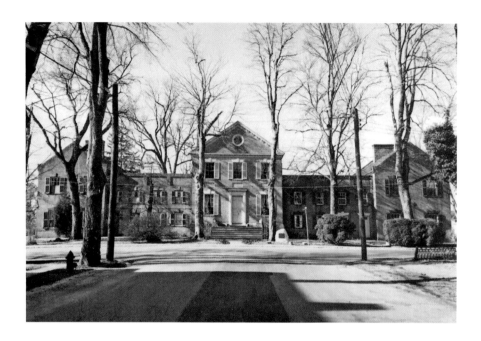

Above: Teackle Mansion in Princess Anne. *Courtesy of the Edward H. Nabb Research Center.*

Left: Portrait of Elizabeth Upshur Teackle of Teackle Mansion. *Courtesy of the Edward H. Nabb Research Center.*

had his office in the left hyphen on the first floor, where he would watch the comings and goings of people at the mansion, which would have included staff, slaves and visitors.

Mr. Teackle was away on business most of the time, which left his wife, Elizabeth, back at the mansion running the house and their personal lives. At first, Elizabeth Teackle felt displaced living in the mansion. She was born and grew up in Accomack, Virginia, with all the amenities of a thriving Eastern Shore town. The mansion was way out in the dusty country, and she had no friends. As lady of the manor house, she had a lot of responsibility. But we know from her letters to her sister that she came to love her home and her gardens. It was Elizabeth who designed all of the gardens and nurtured the sense of home. The Teackles had one child: a daughter, also named Elizabeth.

The house was completely finished by 1819. In 1828, just nine years after the house was finally completed, the Teackles lost the mansion and most of their holdings due to the failure of Mr. Teackle's business. Mrs. Teackle's brother-in-law bought it at auction and eventually gave it back to her, but she died four years later. Then it sat empty a few more years. Mr. Teackle got it back again for a short time, but he sold it. It was never again a real family home. After his death, Littleton Dennis Teackle's estate was valued less than twenty-five dollars. He and his wife are said to be buried in unmarked graves at the St. Andrews Church graveyard in Princess Anne. Many years later, markers were erected with their names in the cemetery as a memorial.

The property was subdivided and sold off in parcels, and houses were built all around the mansion, giving it the neighborhood setting it has today. The building served many purposes, and for a time, it was cut up into apartments and even used for student housing. Then it fell into dreadful disrepair. Local people in Princess Anne formed nonprofits that have carefully restored the mansion and offered it back to the community as a historical treasure.

Neighbors have seen shadows cross the windows of the mansion at night. Sometimes they report seeing what looks like a flickering candle and the silhouette of a woman. People believe this is the spirit of Elizabeth Teackle still running her household. The Princess Anne Police say that motion detectors in the house seem to go off often. When they investigate, there's no sign of anyone being there—except one time. One officer said that one night, when the alarm went off, he was on call. He met someone from the historical society at the mansion, and they went through the building together. They went to the third-floor stairway, which is so narrow that one has to turn sideways to ascend the stairs. The door at the top of that stairway is always

closed, but on this night, it was wide open. When the officer was halfway up the stairs, the door at the top slammed shut. The historical society person said, "Do you have your gun?" He replied, "Yes, I have my gun." But he wasn't going to use it. They left quickly. Neighbors say the alarm goes off all the time, and the alarm also goes off at the Sara Martin Dunn House, another restored home open to the public behind Teackle.

The folklore collection at the Nabb Research Center has an entry by someone who was hired to come in and clean the mansion twice a week. She said that she was never alone in that house. She said that the cellar was so creepy and that there's a picture of a man with a beard and mustache in the drawing room. He's scary looking, and his eyes follow you. Someone took it down and put it facing the wall in the hall because so many people complained. They say it was a picture of a man named Aaron Quimby, who was was the husband of Elizabeth Teackle (daughter of the Teackles). Also, a student reported that while he was in his apartment (in Teackle Mansion), he was always hearing strange noises. The windows would randomly open and close. Students would hear footsteps in the hall in the middle of the night. One night, a woman dressed in what looked like a long white nightgown came into a student's room, walked over to the window and stared out. He got his things and left. He moved out the next day.

Delmarva Paranormal Researchers spent a night at Teackle Mansion doing an investigation. They found some interesting EVP (electronic voice phenomena) evidence. At the bottom of the third-floor stairway (where the police officer saw the door slam), the batteries for their camera equipment all drained. Several of the investigators felt a cold wave come over the area, and the electronic temperature reading equipment registered a drop in temperature in that space. The spirits of Teackle Mansion are calm and friendly. Perhaps that's because there are spirits all around them—at the house across the street, at the jail down the street and at the courthouse several blocks away. Princess Anne is so haunted, and some of the stories so disturbing, that we don't allow children on the tour.

Judge Stanford's Mansion

Just across the street from Teackle Mansion is a large pre–Civil War home with a wide front porch. It had been a doctor's house and had also served as a school. Judge Henry Stanford purchased the property in 1896. And he

Spirits of Somerset, Wicomico and Worcester Counties

The Francis Barnes House in Princess Anne, once home of Judge Henry Stanford.

and his family had a nice life there—until he committed suicide. The owner of this house approached me about her house being haunted when I was interviewing someone at Teackle Mansion. She said that a doctor owned the house and that he committed suicide by cutting his own throat in the upstairs bathroom. She said that she's lived in the house for more than twenty years and never been able to take a shower in that bathroom. When she's in there, these bursts of energy occur, and the room feels electrified. She said that when her granddaughter was a toddler, the child would talk to invisible people like they were actually there and responding. The woman said that they were all used to it, the house was home to her and they loved it there... but they were not alone.

After hearing her story, I did some research and found two doctors who had owned the house: a Dr. Louis Morris, who bought the house in 1863, and a Dr. Ruby, who owned the house in the late twentieth century. Dr. Ruby did not commit suicide. There was no evidence that Dr. Morris did either. But I came upon some commentary offered by a Salisbury University student who was in the folklore class. His mother knew Mrs. Ruby:

> *The Stanford Mansion is right across from Teackle Mansion. Years ago Judge Stanford and his housekeeper lived there. The judge committed*

Judge Stanford and his family beside their home in 1898. *Left to right*: R. Ella Stanford, Marion Waller Stanford (wife of Judge Stanford), Emily Stanford and Judge Henry Stanford. *Courtesy of the Edward H. Nabb Research Center, Stanford Family Collection.*

> suicide. My mother was good friends with a Dr. Ruby who used to live there, and his wife used to tell her all the things that went on in there. She used to see Judge Stanford coming down the stairs reading his books, and even Judge Stanford's housekeeper one time came and sat on Mrs. Ruby's son's bed.... One day she was rocking in her rocking chair and it stopped and she couldn't get it to rock anymore and she thought it was her son playing tricks on her, so she told him to stop it, then she felt a cold wind go up her back and she could rock again. Later on she found out that her son wasn't even in the house. She also used to see what looked like a ball of fire in her basement.

Suicides before 1950 are very hard to track or prove. But Judge Stanford's suicide was reported in the papers. The article appeared in the *Tyrone Herald*, a Pennsylvania newspaper:

The Stanford children with an unidentified woman in front of their home, the Francis Barnes House. *Courtesy of the Edward H. Nabb Research Center, Stanford Family Collection.*

Judge a Suicide

Maryland Jurist Ends Life with Razor While Ill
Salisbury, MD, August 11, 1917

Associate Judge H.L.D. Stanford died in Peninsula General Hospital after he had been brought to the institution from his home at Princess Anne, where medical attention was given him for wounds, which he inflicted upon himself in his bedroom at his home in Princess Anne, by drawing a razor across his throat.

Judge Stanford had been in ill health several weeks, having suffered an acute attack of Bright's disease, which caused temporary mental depression, but not to such an extent that his immediate family had any doubt of his recovery.

Bright's disease was what we would call kidney inflammation today. It could have been kidney stones, which could be incredibly painful, or an inflammation of the kidney itself with other complicated symptoms. While Judge Stanford did commit suicide, there's no indication that he had chronic depression. We know that he was born in Somerset County and was sixty when he died. He was educated in the public schools in Salisbury and Baltimore, and in 1894, he formed a law practice with Joshua Miles in Princess Anne. He practiced law until he died. In 1905, he was a delegate in the Maryland General Assembly. And we know that he married Marian Frances Waller, who was twenty years younger than he, and that he was very proud of his four children: one son and three daughters. We have every reason to believe that he loved his home and his life. After his death, Marian and the children moved away to be with relatives, so it is likely that they couldn't afford the home without his income. Perhaps they're all home now, but just living on the other side of the veil.

The Gray Eagle

The stone building two blocks up from Teackle Mansion looks more like a house than a jail. Many of these small-town jails looked like houses because they actually were houses. A sheriff or deputy or jailer lived on the first floor of the jail with his family, and the prisoners would be housed on the second

Spirits of Somerset, Wicomico and Worcester Counties

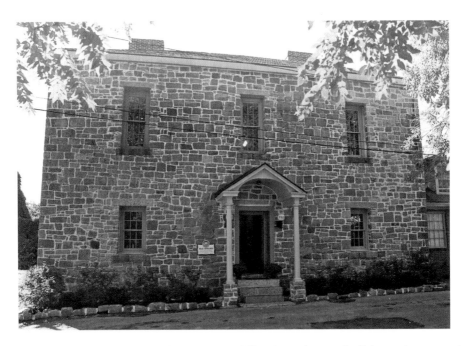

The Gray Eagle served as the Princess Anne Jail and now houses the Princess Anne Police Department.

floor. The jailer's wife would take care of the domestic needs of the prisoners such as food and laundry, and the living quarters were part of the pay. The Princess Anne jail is called the Gray Eagle because of its gray walls. It's the only structure in the county with load-bearing stone walls, as stone is hard to come by on the Eastern Shore. The original jail was built on this site in 1857, but it burned down in a fire in 1902 that was started by the prisoners. As a way to fireproof the new jail, it was built with stone and a slate roof. The interior is concrete and steel. Today, the jail has been fully renovated and converted to the Princess Anne Police Station. But there are ghosts inside those walls, and they still make themselves known.

The Princess Anne jail was the site of a horrible murder in October 1933. An eighty-one-year-old woman named Mary Denston was collecting her rents. An African American man from Pocomoke named George Armwood assaulted her. Armwood was working on a nearby farm owned by John Richardson, who urged Armwood to rob Mrs. Denston because she was an easy target. According to the newspapers, George Armwood reached down Mary Denston's dress and pulled out the cash from her undergarments, where she had stashed it. Mrs. Denston was pushed to the ground and was later able to identify George Armwood. Being an African American male

accused of attacking an elderly white woman in 1933 was an exceptionally bad position to be in. The lynching of black citizens and vigilante justice were real dangers. A recent case where a black farmhand murdered an entire white family in Worcester County—and then got sent to Baltimore, where the locals couldn't touch him—enraged the entire Lower Shore community. They wanted to mete out their own justice.

The police were advised to avoid bringing Armwood to Princess Anne for fear he'd be lynched. So they took him to Salisbury and found a mob waiting there for him. They managed to avoid the Salisbury mob and headed for the Western Shore, and Armwood was held there. Judge Robert Duer, who was the respected voice of authority in Princess Anne, was hounded by the community to get Armwood back home and try him locally for the crimes against Mary Denston. Judge Duer petitioned Maryland's Governor Ritchie to release Armwood and allow him to return to Princess Anne, where Duer would guarantee Armwood's safety and a speedy trial. Ritchie released Armwood and sent him back to Princess Anne. A crowd of nearly one thousand people was waiting—obviously to lynch Armwood. Judge Duer addressed the crowd outside the jail, saying, "I know almost all of you. I am one of you. And I promise to have a speedy trial. There is no need for violence. Now go home. I will hold you to your honor."

The crowd dispersed and went home. But then, Judge Duer went out to a dinner party, and once he was gone, that crowd came back—with a battering ram. They even brought cameras to photograph the spectacle of them breaking down the door to the jail. The overpowered twenty-five officers then ran up the steps to find Armwood hiding under his mattress.

They beat him and cut off an ear. Then they dragged him down the steel steps by his feet so that his head bounced on every step. They took him outside, tied him to a truck and dragged him around town, stopping in front of Judge Duer's house, where they hanged Armwood from a nearby tree. Then they took him down, dragged him back to a telephone pole near the courthouse, hanged him again and set his body on fire. George Armwood's dead body was dumped in a vacant lot near a lumberyard about two blocks from where he was set on fire. None of the men who participated in his murder was ever brought to justice. The community stated that all of the participants were from out of town, and they complied with the necessary actions to make it seem so. The incident cost Judge Duer his next election.

When this kind of violence occurs, it can't help but affect the energy of the place. The police tell of instances that happen regularly in the jail,

which is now their office. There is an interview room where police officers take statements from witnesses, victims and perpetrators. The interviews are recorded and then sent off to be transcribed. The police have gotten calls from transcribers asking them who the third voice is. They say that they can't make out the words of that third voice. But there is no third voice—at least not a human one. Other incidents include seeing what looks like human shadows moving across the wall, without a human present to cast the shadow. The upstairs is now a gym, bathroom and kitchen area. One of the staff members brought her toddler into work for a few hours on a weekend. He was normally very shy, but he wandered away from her while she was working on some papers. He headed up the stairs. When he came back down, his mother asked him, "What did you see upstairs?" expecting him to say a bicycle or a kitchen. But instead he said, "a woman looking out the window." When he got home that night, he told his sister the same story, only he added that she had died and she was creepy. It turns out that female prisoners always had the run of the building. Sometimes they did housekeeping and sometimes they worked in the infirmary, which was located where one of the side offices currently exists. Every time our ghost tour meets a Princess Anne police officer on the walk, the officer will tell us a recent story.

When a group of people collectively listens to the story of what once happened in a place and react emotionally together, it produces a kind of force. It creates a doorway for communication with the spirit world. Signs appear. Coincidences occur. The spirits make themselves known. And this happens all the time in Princess Anne. You can't just talk about a broken-hearted woman who has lost her family, her home and her identity; or a judge who slashed his own throat as a way of escaping excruciating pain; or a man who was publicly murdered without coming to the brink—the gateway to that other world, that place where those spirits exist. We've had African American guests listen to our stories and feel like they're being choked or have difficulty breathing. It's no wonder. The content is harsh, and collectively we're calling the spirits back when we retell the stories with such emotion.

Princess Anne had another lynching as well, not too far from where George Armwood was killed. But it was thirty-six years earlier in 1897. William Andrews was accused of rape. The newspapers said that he was hanged and then shot somewhere within sight of St. Andrew's Episcopal Church. On the first ghost tour I guided in Princess Anne, we had a young woman on the tour who took a lot of pictures along the way with her smartphone. Near the end of the tour, she asked if she could show me something. She

looked terrified. I glanced at the picture on her phone, and the image wasn't subtle. It was the image of a man hanging from a tree. The outline was near perfect—his shoulders, hands, legs, shoes. It was so disturbing that I ended the tour immediately.

That's the kind of powerful sign that surfaces in Princess Anne. But that wasn't the only instance of spirits reaching out to us that night. As I walked to my car, a group of young women approached me. They said that they were Mary Denston's great-granddaughters, and they wanted me to know that George Armwood raped their great-grandmother. They had tried to bring this up in years past when people were discussing the lynching, but they were treated with disrespect. They wanted me to know that it wasn't as simple as a man reaching down an old lady's dress and her falling down. It was violent and humiliating, and Mrs. Denston died shortly afterward. And these girls wanted someone to hear that story. So I heard. And I include it now when I tell the story. It is important to tell our stories with care and share what comes to us.

CRISFIELD HAUNTS

Crisfield is the southernmost town in Maryland, situated way out at the end of a peninsula that is fifteen miles from the highway. It was founded in 1663 and only spans about three square miles. It has always been a watermen's town, with seafood harvesting, packing and shipping as the economic engines that created wealth and defined the town's character. While there are only a few packinghouses left, Crisfield embraces its heritage and still markets its seafood and waterfront. At one time, Crisfield was a bustling port city, the second-busiest port in Maryland. But with the decline of the seafood industry, the town is only a shadow of its former self, with about 2,700 inhabitants and a slow economy. But it has some of the richest natural resource assets on the East Coast. Tourism is a strong industry.

The town has produced some pretty influential characters. The man who patented the process of lining jar lids with cork instead of rubber gaskets with wire tension devices came from Crisfield. His name was Riley McCready. He took his idea to Chicago and put it to use in a manufacturing operation that eventually became Crown Cork and Seal. The founder of Del Monte Products, James Wesley Nelson, came from Crisfield, as did the only two Marylanders to pioneer an American art form recognized by the National Endowment for the Arts: brothers Lem and Steve Ward, who are famous for turning waterfowl or decoy carving into art. Crisfielder Harry Clifton Byrd served as president of Maryland University for eighteen years. Maryland's fifty-fourth governor, J. Millard Tawes, was from Crisfield, and he still holds the record for being the only person in Maryland's history who has occupied

all three positions on the Board of Public Works: governor, treasurer and comptroller.

The spirits of Crisfield are present at the waterfront, in houses along Somerset Avenue, around McCready Hospital and out on Janes Island. And the Crisfield Library is also a mausoleum.

Who Haunts McCready Hospital?

When I first started inquiring about ghost stories in Crisfield, the most common mention by the locals was McCready Hospital. It seems that in the old part of this small community hospital, there are some strange goings-on. From time to time, we will have McCready employees on our tours, and they always have stories to tell. File cabinets opening and closing, noises from unoccupied rooms, doors that lock themselves, conversations from phantom talkers, spectral figures walking the halls, the strange smell of sulfur wafting about and the sound of footsteps attached to no living person—all of these are stories people have told about McCready Hospital. Almost all of the events take place in the old, original part of the hospital.

Old wing of the McCready Hospital in Crisfield.

Spirits of Somerset, Wicomico and Worcester Counties

The hospital was opened in 1923 largely through an endowment offered to the town by Caroline Pitkin McCready, the widow of a hometown boy, Edward McCready, who was the son of a Crisfield shipbuilder. Edward was killed in a car accident with their eight-year-old daughter, Suzanne. He grew up in Crisfield and became attached to the land like so many who grew up there. His brother developed a patent for sealing jars with cork and moved the operation to Chicago. The company eventually became Crown Cork and Seal. Edward followed his uncle to Chicago to work in the company, and it was in Chicago where he met Caroline, who was from a wealthy family. They married and settled in the upscale Chicago neighborhood of Oak Park. They had one daughter, Suzanne, and a full-time nanny.

Like Lilyan Corbin, the Crisfielder who left town to become an actress and is memorialized at Corbin Library, Edward McCready yearned for summers in Crisfield. He decided to build a summer home on property that his mother's family had owned. The McCreadys took a road trip east in a brand-new automobile in the summer of 1919 to visit Crisfield relatives and get the summer home project moving. They dropped Caroline off in Atlantic City and then continued south to Crisfield. They concluded their visit in September, and the morning of their departure, Edward wired Caroline to let her know that he was leaving Crisfield and en route to get her. He piled the front seat of his Pathfinder touring car with the presents and secured Suzanne and the nanny comfortably in the back seat for the long ride to Atlantic City. In those days, it took one hour to get from Crisfield to Westover in a car—a ride that takes roughly fifteen minutes today.

When they reached the railroad crossing in Westover, Edward did not see an oncoming train. It hit his car on the driver side, and he was killed instantly, as was the nanny. Both the nanny and Suzanne were ejected and thrown fifty feet. There was a small hospital in Crisfield, and people at the scene saw that Suzanne was still alive and tried frantically to transport her to that little hospital for treatment. But Suzanne died along the way. A local undertaker took care of the bodies and laid them out at the small hospital. The hospital nurse stayed with the bodies and waited for Mrs. McCready to arrive. Dr. R.R. Norris and his wife headed out to Atlantic City to escort Caroline McCready back to Crisfield to retrieve the bodies of her dead loved ones. Caroline arrived, and after spending a few moments with the deceased, she asked the hospital staff how much she owed them. Nurse Florence Webb Smith—herself a widow—replied, "Why Mrs. McCready, you have no bill from us. We're only sorry we couldn't do more for you."

Haunted Lower Eastern Shore

Caroline McCready was so grateful to this community for their kindness and care that she donated money to build a hospital for the community. She intended to have it built on the site where they had planned to build their summer home, but a more suitable location with higher elevation was secured. On Valentine's Day 1922, they broke ground for McCready Hospital. It was opened in May 1923. To the right of the door, under the portico, there is a large bronze tablet with the following dedication inscription:

> *Edward McCready Memorial Hospital*
> *They shall not grow old, as we that are left to grow old:*
> *Age shall not weary them, nor the years condemn.*
> *At the going down of the sun and in the morning*
> *We will remember them.*
>
> *Born* *Died*
> *May 6, 1860* *September 13, 1919*

While I've never heard any story about Edward McCready's spirit haunting the hospital, I have heard speculations that seafood magnate Richard Christy's spirit may be there. Richard was from the Christy family of George A. Christy & Son Seafood. They were packers and shippers of seafood ranking in the top ten of American shippers at the time. They were also one of the largest employers in Crisfield. There is a story that circulates around Crisfield about Richard Christy that he was a mean sort. Many people in the town will say this—even nice old ladies who rarely say a bad word about anybody. I have only ever spoken to one person who did not describe Richard Christy as mean: his grandson. I was embarrassed to have imparted such vile words against his grandfather in his presence. One must take into account the times. I've actually heard the same nasty adjectives used when referring to many of the old packers. There was social tension between the owners of the packinghouses and the watermen and packinghouse workers. A large part of the population worked on the water and in the packinghouses. The packinghouse set the price of the seafood. It dictated the price paid to the watermen, and the watermen had little choice but to accept. The same was true for the packinghouse workers. The packers set wages. So in a community where wealthy seafood magnates were getting richer, the watermen and packinghouse workers couldn't generate wealth. Resentment built up that is still felt today in some families. The packers were often considered stingy and selfish, getting rich off the sweat of

hardworking people who were underpaid. This isn't true in every case, but some of that resentment may bubble over when locals describe the character of packinghouse owners.

Although Richard Christy had a reputation among many as being mean, he also did a lot for the business community in Crisfield. Historian Woodrow T. Wilson cited several instances of Richard Christy sponsoring people who wanted to start a business and participating in business development in the community. And Christy's grandson stated to me in casual conversation that although Richard Christy had a harsh side, he was a loving grandfather with whom he shared wonderful memories.

In 1981, Richard Christy, who was in his late sixties, became ill and needed surgery. He was taken to McCready Hospital and prepared for the surgical procedure. Commentary from hospital workers stated that a storm was coming across the Tangier Sound. Richard Christy was alone in a hospital room with the door closed. Apparently, lightning hit the air conditioner that was in Richard Christy's room and fried everything in the room—including Richard Christy. When people tried to enter, the doorknob was too hot to touch. Once they got the door open, there was the smell of sulfur about the room, and Richard Christy was deceased. There were stories about a man seen entering Richard Christy's room just before the lightning struck. No one knew who he was, and no one saw him leave. Others said the smell of sulfur was the residue left by the angel of death. The story grew from there and is now part of Crisfield's folklore and legends.

It was after this incident that workers began reporting unexplained events in the hospital, most of which were noises. People would hear entire conversations on a floor that was unoccupied. The experiences, according to the commentary, would mostly happen at night. The upper floor in the old building would be completely empty, and yet staff conversations were heard, along with file cabinets opening and closing and what sounded like office chairs rolling across the floor above. Lights would turn on and off by themselves. People began to refer to the unexplained activity as the ghost of Richard Christy. The following commentary by two hospital workers makes that reference:

> *I was working the day Richard Christy died. Several of the nurses reported that a small well dressed man asked which room Mr. Christy was in. The nurses told the man that the room was at the end of the hall next to ICU. The nurses watched him go into the room. Several seconds later there was a power surge and smoke came from his room. The man was never seen*

leaving the room. I remember the nurses were frightened by the incident. I think several of the nurses are still working there.

–Brent C., 2009

I used to work there several years ago while my father was CEO. I was the administrative assistant to a lady on the executive team whose office was on the second floor of the old building and it was weird being up there after hours like that…. It was after dark and the silence was really freaky. I always felt like I was being watched.

–Enid K., 2010

Richard Christy died on September 15. Edward McCready was killed on September 13—almost the same day sixty-two years apart. Still today, people who work at McCready Hospital will show up on our tours and mention the latest paranormal event. The stories have changed, and no one talks much about Richard Christy anymore. The physical therapists say they have a phantom singer they hear from time to time. "It's all good," one of them said. "They make themselves known, but we're all happy here."

On that note, I must give some personal testimony. Two years ago, I was suffering with chest pains, and my husband ran me down to McCready, which is only five miles from our home. To go to the big hospital in Salisbury would have been thirty-five miles, and we were frightened that I might not get there in time. Such are the problems of living in a rural area. When I got to McCready, the staff were wonderful. A cardiologist was there within twenty minutes, and I was well taken care of once I was stabilized. The next morning, I was transferred by ambulance to Salisbury. I can't emphasize enough how kind and caring the McCready staff was. These small community hospitals are so important. Haunted or not, I'm so glad that we have this hospital. Thanks, McCready.

THE COASTING CAPTAIN AND PHANTOM FIRST MATE

Captain Leonard Tawes was born in Accomack County, Virginia, in 1853 and grew up to become one of the most well-traveled sea captains in Crisfield—and certainly one of the most famous storytellers. "Captain Len," as he was known, told a famous ghost story about his experience with

Spirits of Somerset, Wicomico and Worcester Counties

The *City of Baltimore*, Captain Leonard Tawes's three-masted schooner. *Courtesy of the Somerset County Library.*

a first mate he hired off the docks in Baltimore. That story was carried by several Eastern Shore newspapers and is reprinted here.

Captain Len was known as the "Coasting Captain" because he was the last captain to operate a non-motorized commercial schooner. His mother died when he was very young, and his father wasn't able to support the family, so Captain Len went from home to home doing work for local families until age fifteen, when he got a job on a ship and found his passion. Around 1884, when he was in his early thirties, he became part owner of the *City of Baltimore*, a three-masted wooden schooner that was 138 feet long. He was the captain of that vessel for twenty-two years and conducted more than sixty voyages to the Gulf of Mexico, West Indies and South America.

His granddaughter Elizabeth wrote that after retirement, he wanted to stay busy, so he took a job as a relief watchman for oyster beds in the Pocomoke Sound. His job was to protect the oyster beds from poachers while keeping watch from a shanty placed on pilings out in the sound just beyond the horizon. Elizabeth said that he loved the nights spent in that shanty, which was equipped with a coal burning stove, table, two chairs and two bunks. It was in that shanty, just after retirement, that Captain Len began writing about his travels. Using his log books for reference, he finished out his journals from a summer kitchen attached to the back of his house—a house that still sits on Somerset Avenue, with the summer kitchen just as he left it.

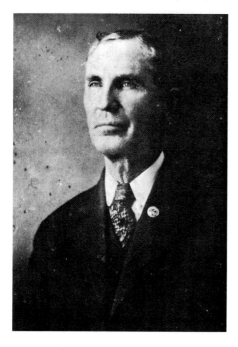

Portrait of Captain Leonard J. Tawes of Crisfield, also known as the "Coasting Captain." *Courtesy of the Somerset County Library.*

He wrote the stories for his oldest grandchild, Mary Anne, who was captivated by his tales of travel. Robert Burgess edited the journals and published them through the Mariners Museum in Newport News, Virginia, in 1967 under the title *The Coasting Captain*. People say that Captain Len's journals are the most complete documentation of a phase of American shipping that was rarely written about—the time of schooners—and *The Coasting Captain* is a remarkable contribution to the annals of maritime history.

In 1893, the captain and his crew met with disaster—a hurricane off the coast of the West Indies. He wrote about an unexplained incident that happened to him and the crew in the throes of that storm and submitted his story to the *Times* in Crisfield. In the story (printed here as it was actually written), he admitted that he doesn't believe in ghosts but also stated that he has no other explanation for what happened:

Gentlemen:

Should you care to use a little space in your paper, I will describe a mysterious occurrence which I experienced on one of my sea voyages, in the year 1893, which I would like to ask some of the "Higher Kulter" to explain. This has been bearing on my mind considerably since Sir Oliver Lodge came to this country several weeks ago. I am not a believer in ghost stories. My theory is that when man dies he is bourne whence no traveler returns.

In the year 1893 I chartered with Messrs Tate Muller & Co., exporters out of Baltimore, to carry a general cargo, mostly bread stuff, to Demerara, British Gueana [Guiana]. I had a mate with me, Thomas Cosden, of Chestertown, who had been in the vessel with me for quite a long time, and who took much interest in the ship and in my general welfare. While loading

the cargo, I could see that his health was failing him and that he was not keeping up with his work. He seemed delinquent and it began to worry me considerably, I having so much to attend to on shore such as buying stores, rigging, blocks, getting water cask put in order, shipping the crew and many other things too numerous to mention which befall a ship master and which cannot be neglected. But after the Mate's long and faithful service on board, I disliked to tell him to leave, which I have since regretted. So I signed him up for the voyage, and after being loaded and getting on board our stores, water, crew, etc., we cleared and sailed.

After a passage of 22 days we arrived safely at Demerara, but about a week before arriving, the Mate became too ill to be of any service, and I had to put him off duty. After arriving I put him in the hospital there and visited him as much as possible, having to be both Captain and Mate kept me busy at the ship, looking after the discharge and count of the cargo when it was not raining, which it did fully half of the time. And every wet place steam with plenty of vapor arising—not much of a place for pleasure seekers in the rainy season, say in June, July, and August.

At last the day came when my cargo was out. I could obtain no cargo there and I must leave light. Before clearing for Barbados where I must go seeking, I went to the hospital to get my Mate. But much to my astonishment the doctor, a very nice Englishman, told me I could not take him that he was too ill to go aboard a ship. I was much grieved to hear this and I told him this man had a mother living near Chestertown, and I would like to take him back home with me. What encouragement can I give him, I asked, and the Doctor replied that he didn't think the man would ever recover.

I forgot what name he gave the disease, but he said that if it broke out on the outside he might recover, and that if it broke out on the inside, it would kill him. And he feared it would eventually turn into consumption. The Doctor told me to break the news to the Mate, of his condition, and it was a trying experience—to tell the young man whom I must sail without, of his impending death and I must leave him there in a foreign country to face the unknown alone. But if I must, I must. So I went upstairs and after some conversation, I had to tell him what the Doctor said. He took it very hard, as I knew he would. I gave the Nurse a little money and asked them to take special interest in him. I told him I would leave all of his wages with the American Consul which is what our Marine laws require to be done when leaving an American seaman in a foreign land.

The time now comes to say goodbye, and I will always see the last look he gave me as I walked down the stairs; he raised up in bed to take

a last glance at me, and those eyes I will see as long as my facilities remain with me.

I sailed for Barbados, but I could not ship a Mate, as there were none to be secured. I arrived at Barbados and after staying there about a week, I chartered to go to Antigua to load sugar for Philadelphia. It was the later part of July and hurricane season was in full blast. When four days out, on a Sunday, I was to the windward to the Island of Martinique, the lighthouse showing plainly at 12 o'clock noon; the wind was blowing very hard and the sea running high, there appeared just ahead on the bow a low island which I had overlooked on the chart. I tried to tack ship and beat up to the windward of the island, but my vessel being light and such sea running that she would not tack. Finally I saw a little narrow channel running between this small island and the main land. I consulted my chart and saw that the channel was clear of obstructions and deep, so I kept her off and ran down the channel between the two islands.

Before dark set in on me I saw that I was clear of any land in sight, so I reefed her down and hove to for the night. I was now in a basin surrounded by a group of islands and a hurricane threatening to come upon me at any minute. If any reader was ever in a West India hurricane he can imagine my feeling—having no Mate and poor crew to help handle the ship. I kept the first watch, from 8 to 11 p.m. Then to get a little rest, I must go below. At 4 a.m. when two sailors I had left in charge of the Middle Watch, called me, a big sailor named Pete said to me "Captain, the Mate has been on board." Nonsense, I answered, "What are you trying to give me." "Yes, sir," he said, "he was certainly here and the other man saw him too. He walked all around these decks." I asked the sailor what time it was that he saw the Mate on board, and he replied at 2 o'clock a.m. I asked the other man and he substantiated the story exactly as Peter had told it. When the day broke and light came I saw the Island of Antiqua bearing to the North West of me. I made more sail, kept off and ran down to the island to take a pilot and went into the harbor of St. Johns where I came to anchor.

I loaded there a cargo of sugar and went to Philadelphia, discharged the cargo and from there went to Kings Ferry, Florida, where I loaded lumber for Demerara. I had a long and rough passage and after rocking about on the ocean for 37 days I arrived safely at Demerara. As soon as the ship was safely moored and entered at the Custom House, and I had deposited my papers at the American Consulate, I went to the hospital to inquire for my Mate, who I had left there four months before. They told me he was dead.

I asked them when he died and they gave me the day and hour and it tallied exactly with the day and hour that the two sailors saw him walking around.

If anyone wishes to substantiate this statement, they can do so by writing to the hospital in Demerara and getting the date and hour of his departure, and then referring to my log book up my garret at home. I will wager a fifty dollar suit of clothes that the date and hour will prove the same.

Trusting I have not worried you with too long a story, which I could (have) made much longer, I am

Respectfully yours,

Capt. L.S. Tawes.

The article was published in May and June 1920 in both the *Times* and the *Kent News* in Chestertown, Maryland. Captain Tawes is buried at the Crisfield Cemetery next to his wife, Mary, and their child, Samuel, who died when he was eight years old. The family plot has an iron fence border.

The Library Mausoleum

The only library in the state of Maryland that also serves as a mausoleum is located on Main Street Extended in Crisfield, Maryland, just east of the only traffic light in town. Inside that little white building, in a niche carved into the wall above the circulation desk, is a large urn with the cremains of Lilyan Stratton Corbin, who died in 1928 in a terrible car accident. She was a native of Crisfield who came from a broken home; she had a first-grade education and boarded a train at the age of sixteen—the same daily train that transported the seafood harvests of Crisfield watermen to northern markets. Her dream was to become an actress. She saved her money from cleaning Crisfield houses to buy a one-way train ticket, and nobody knew of her plans. She stepped on a train bound for New York City and left her old life behind.

Lilyan earned money by selling New York newspapers. She was successful at reinventing herself and eventually became an actress, an author and a wealthy investment banker. But like many Crisfielders, she felt that draw—that magnetic pull back to her hometown. Although she lived in New York

Postcard view of the Lilyan Stratton Corbin Library in Crisfield. *Courtesy of the Edward H. Nabb Research Center.*

and New Jersey, embracing the glitzy, glamorous lifestyle there, she always had a home near Crisfield, and it was always her plan to make Crisfield her final resting place. Now she rests in a niche behind Plexiglas—surrounded by books and local people in the community who want to read and learn and find a quiet space. Her name is written over the library entrance, as well as on a plaque just below the niche that holds her cremains:

> *Lilyan Stratton Corbin*
> *Daughter of Alexander Corbin and Henrietta Tyler*
> *Beloved wife of Alfred O. Corbin*
> *Born March 6th 1882*
> *Killed tragically in automobile accident*
> *November 1st 1928*

She was born on Old Island in Crisfield and given the name Lillian. Her father worked in the fertilizer plant there, and they lived in a little shack. A sister, Rose, was born a few years later, and eventually the family of four moved into a two-room house on the mainland. From interviews gathered

Spirits of Somerset, Wicomico and Worcester Counties

by Crisfield historian and genealogist Woodrow T. Wilson, it seems that Alex Corbin couldn't catch a break. He'd been pressed into the service during the Civil War by the Union army as a young man and captured by the Confederates. He was held prisoner in a camp in Virginia and eventually received an honorable discharge. But he always struggled financially and had an angry disposition. One local described him as "the cussingest person" he ever knew. It's likely that the Corbins were living in poverty and at the bottom of the social structure. Neither of the girls ever went to school. Alex and Henrietta divorced when the girls were little, and both remarried twice after their divorce. Lillian was sent to live with relatives, and they were kind to her. They put her into the Jacksonville school when she was fourteen. The school served all grades, and there were many pupils. Her teacher, Mrs. Della Cullen, couldn't give Lillian the private attention she needed with such a large class. So she let a bright six-year-old student, Miss Willie Riggin, tutor her. That was a bit humiliating for Lillian. Willie remembered Lillian as shy and well liked, one who caught on to things quickly. No one knows if the schooling was too difficult or if it was too humiliating to be tutored by another student, or if her desire to become an actress overpowered her desire for education. Perhaps it was a combination of all three. Lillian quit school, and in 1898, she boarded that train for New York and never looked back.

In those first years in New York, Lillian met a wealthy man named Mayall who was a former Wall Street banker. He took a keen interest in Lillian. Some say they were married, and some say they weren't. But during that relationship, Mr. Mayall not only taught Lillian the fundamentals of investment banking, but he also taught her how to become accepted in the social circles of upper-class New York City. In 1904, he passed away and left his fortune to Lillian. She fulfilled her dream of becoming an actress and performed in silent moves and on stage. It was then that she adopted the name Lilyan Stratton Corbin. She began to write and eventually authored four novels. About a year after Mr. Mayall died, she married Frank Campeau, who was a silent film actor in New York. Lilyan and Frank were a high-profile couple, and their names appeared on billboards and marquees in New York and other big cities.

Frank and Lilyan bought a house near Crisfield and visited in the summer. They traveled all over the world, and Lilyan's fame and popularity grew. It's likely that it eventually overshadowed Frank's popularity. He began to squander money and pursue interests outside his marriage. Lilyan was both humiliated and going broke. She went to Reno, where they had both had lived for a while and performed as actors, and she got a quick divorce. She was financially strapped and had to rebuild her life again.

She met a man, Alfred, in New York who had emigrated from Holland after World War I. He had lost all of his property, possessions and family in the war—save for one son. He and his son were trying to start a new life in America, and Lilyan offered him some advice on how to invest money. They fell in love and were married, and because Alfred's name was too hard for Americans to pronounce, he adopted her last name, Corbin. Lilyan showed Alfred the fundamentals of investment banking. Together they built a fortune and enjoyed a life of travel, and Alfred became one of the county's leading investment bankers. Lilyan continued with writing and acting. One of her novels was entitled *Reno*. At the time, Reno, Nevada, was considered the divorce capital of the country. Lilyan wove a tale that featured a character who had been exploited and humiliated by her husband and had to seek a divorce in Reno. In the book, she referred to the divorce process as "a bit like attending one's own hanging." The book was popular and was featured in a 1922 article in the *St. Louis Post-Dispatch*, where Lilyan was quoted as saying:

> *The divorce court should only be appealed to as a last resort, to free some tortured soul from a life of misery, caused by humiliation, shame and hatred, the very essence of all evil. When the sacred state of matrimony becomes so profaned and degraded that it soils everything it comes in contact with; when even the minds of our children are poisoned and distorted by the atmosphere, and the last ray of hope has vanished, only then the hour has struck to ask the law for justice.*

In that same article, she made reference to how happily married she and Alfred were and how there is hope for a good life after divorce. As Lilyan and Alfred continued to enjoy life, they summered in Crisfield and kept close contact with Lilyan's friends and relatives. Sadly, on November 1, 1928, in Parsippany, New Jersey, Lilyan and her secretary, who was also her niece, were driving in Lilyan's new convertible. Lilyan's scarf blew across her face, temporarily obstructing her ability to see the road. She lost control of the vehicle, and it crashed and caught fire. Both women were burned to death.

Alfred was devastated. He was quoted more than once shortly after her death as saying, "Everything I have I owe to Lilyan." He had Lilyan's body cremated, as it was burned beyond recognition, and he decided to erect a memorial to her in Crisfield. He secured a piece of land covered with lovely pine trees from Captain Leonard Tawes. He had a mausoleum designed and built on that land and designed it as a memorial park. Lilyan's cremains were place inside the mausoleum

The portrait of Lilyan Stratton Corbin that hangs in the Corbin Library.

along with memorabilia, including a portrait, copies of her books and photographs. Alfred also built the public library in her memory on Main Street Extended and named it the Lilyan Stratton Corbin Library. The library architecture looks eerily similar to a mausoleum.

But an extravagant memorial tomb in a small rural town has its challenges. There was trouble with vandals breaking in and defacing the mausoleum, so Alfred relocated Lilyan's cremains and the memorabilia to the memorial library. There was a large dedication ceremony in about 1932. The portrait from the mausoleum was hung in memoriam on a library wall. Alfred abandoned the mausoleum and the land, and eventually Woodson Elementary School was built on that site.

After the 1932 dedication, Alfred faded away, as did Lilyan's memory. The urn with her remains was put on a shelf with the encyclopedias, and when asked about the portrait on the wall, some people said that it might be Lilyan, but it also looked a lot like a former librarian. During the 1980s, the library underwent a renovation, and Lilyan was given a bit more respect. That's when they carved the niche into the wall and placed the urn inside and the memorial plaque on the wall beneath it. Today, the library has an uncertain future. The County of Somerset needed a larger library to serve the community and made plans to build one on the other side of town. The county (which now owns the library) found that Alfred had attached a condition to the deed that prohibited the local government from selling the building. If it was not to be used as a memorial library, the ownership of the property would revert back to the Corbin heirs. So the new library is now completed. No one seems to know what will become of the old library once the new one is opened.

People wonder if the library is haunted, being that it also serves as a sort of memorial tomb. When I asked a librarian, the answer was a definite no. But if you hang out in the library for a little while and chat with some of the volunteers and faithful patrons, you'll hear them say that they sense Lilyan's presence. In a 2010 interview, a volunteer said that on more than one occasion, the books in the Maryland regional section have reshelved themselves—or so it seems. "I know they were on the cart," she said joking. "But when I walked back there to move the books on the cart back on to the shelves, my work had been done. Now *that's* the kind of ghost you want to have. I wish she'd come home with me and help with the dishes."

In the summer of 2016, Somerset County built a modern, brand-new library out near the highway, overlooking the Tangier Sound. The Corbin Library now sits empty with an uncertain future. And Lillian's remains are still inside.

Old Ailsey's Light

From time to time, campers at Janes Island State Park in Crisfield will report seeing a strange light hovering above the salt marsh across Daugherty Creek Canal. Unlike swamp gas, it moves in a convulsive manner—hovering and then shooting in one horizontal direction before

Spirits of Somerset, Wicomico and Worcester Counties

Abandoned home on the Dublin Road, Princess Anne.

burning out. And some reports state that the light is accompanied by the sound of a high-pitched moan—like a cat or woman wailing. The light isn't reported to be white like a comet or a meteor. It's orange like a fireball. Some people say that the light is nothing more than swamp gas being released from the marsh, but swamp gas doesn't dart around. It bubbles up and then dissipates into the atmosphere.

The light phenomenon that the campers report has an eerie similarity to an old tale told by watermen and hunters about a similar light in the same area a long time ago.

The salt marsh across from the campground wasn't always a marsh. There was a time many years ago when people lived on that island and had productive lives with small houses and gardens. Up at the very north end of the island, in a place known as Long Acre, an old woman lived in a house all by herself—except for her clowder of cats. Everyone knew her as "Old Ailsey."

Old Ailsey didn't mind being alone. She kept busy with her house and her gardens. She kept chickens and ducks and feasted on fish, oysters and terrapin. Her cats kept her company, and no matter what the season, Old Ailsey loved the land she lived on. Every night she'd sit on her porch and watch the red sun slip into the horizon across the Tangier Sound. "There's

no sunset so beautiful as a Tangier sunset," she told herself. And living there in that little paradise on Long Acre was enough to keep Old Ailsey content. Every so often, friends would come in by boat, check on her and bring her some supplies. They'd often try to convince Old Ailsey to leave Long Acre and come on to the mainland, where she could be looked after. But Old Ailsey would never leave.

One summer day, Old Ailsey was in her house cooking supper in her big fireplace. While stirring the coals, she didn't realize that one flaming ember had popped out of the fireplace and landed on the hem of her long dress. Before she knew it, the dress was in flames. She had no water in the house, so she ran outside, but as she ran, the fire spread. She looked for her pail of fresh water but was too overcome with fear to give much attention to the search. She began to scream and shriek, and as the flames reached her skin, she ran for the shoreline hoping to be able to jump in the water and extinguish the flames. But the fire advanced quickly, and soon her flesh was burning. Old Ailsey continued to howl in pain and fell to the ground trying to beat the flames down. She burned to death.

Friends who came to check on Old Ailsey a few weeks after her death found her charred remains just a few feet from the shoreline. They buried her near her garden.

Years after her death, hunters and fishermen who were in Flat Cap Marsh or the Tangier Sound at night reported occasionally seeing a strange light as large as a hogshead burst out from Old Ailsey's deserted house. The light would then travel two or three hundred feet in a horizontal direction, getting brighter by the second. It would stop just before the shoreline and then dissolve. That light became known as "Old Ailsey's light." It played before the observers like an old memory—a memory of a poor old woman engulfed in flames, running in a panic from her house trying desperately to extinguish the fire until it finally consumes her, just feet away from the water that could have saved her.

No one ever lived in the house after Old Ailsey died. The abandoned home and the silhouettes of her cats occasionally seen around the old structure kept her memory alive for almost one hundred years. Eventually, the house surrendered to the elements, and the cats died off. The sighting of Old Ailsey's light became less frequent until no witnesses were left. No one could remember seeing the strange light as large as a hogshead bursting forth from where the house once stood. Old Ailsey became a memory, but the old people kept the memory alive by telling the story, and that pattern repeated itself for nine generations. Even today, almost two hundred years since Old Ailsey met her death, storytellers entertain summer campers at Janes Island by retelling the story of her death and the mysterious light.

Marion Station

When I tell people that I live in Marion Station, I always like to watch their faces. No one knows where it is, except the people in Westover and Crisfield. It's one of nine ghost towns listed for Maryland on Ghosttowns.com. I once inquired what qualifies a town as a ghost town for that site. The reply came back that a town had to fit three criteria: It had to have had a significant population and industry; it had to have had a mass exodus of people leaving the town; and, finally, it had to have some of the old buildings still standing, preferably abandoned. Marion Station qualifies. When the railroad came to Crisfield just after the Civil War, a rail station was proposed for somewhere between Westover and Crisfield. A man named John C. Horsey gave the land for the right of way and the train station building. He got to name the station, so he named it after his daughter, Marion.

The nearby village for the local population was called Coulbourne Creek, and it was located on the water about two miles from the new train station. Eventually, the village relocated to where the new railroad station was placed, and the town adopted the name of the station. The railroad was a huge boon to the economy in Marion Station, as it enabled the shipment of produce—in particular, strawberries—to northern markets. A good bit of wealth was generated during the strawberry boom. But when West Coast agricultural operations developed longer growing seasons, the competition grew, and the wealth in Marion Station dried up. Now it's just a country lane with a few commercial buildings. But there's a lot of history and a slew of spirits that haunt places around Marion Station.

Downtown Marion Station.

SAMUEL TULL HOUSE

There is a Civil War–era house located on East Creek that was once the homestead of Samuel Tull, who was a merchant and operator of the mill at Tulls Corner. The house used to sit on two hundred acres, and Samuel Tull, known as "Big Sam," operated a store, ran a farm and was the master of a large sailing vessel. He and his wife, Maria Catherine, had fifteen children whom they raised in that house. The attic stairs are enclosed, and on the inside of the attic door is an old inscription written in pencil, still visible. It's dated May 14, 1881, and reads, "All gone to the festival but me. Olive Tull."

Olive Tull, known as "Ollie," was the thirteenth child of Big Sam and Maria, and when she wrote that inscription, she was ten years old. Her mother had been dead for four years. Olive married a Whittington and had two children. One died young, and the other was a son. Ollie died in 1915 at the age of forty-four and is buried near the farm.

I interviewed a previous owner about the house having a reputation for being haunted. She affirmed the paranormal activity—some of it quite

Samuel Tull House, near the site of the old gristmill at Tull's Corner.

disturbing. But she said that all activity stopped after her mother (who lived with the family) passed away. The owner also stated that the owners they purchased the house from in 1989 had also experienced unexplained events. The front upstairs room on the right was the master bedroom. From there, both the previous owners and the owner I was interviewing would occasionally hear a little child call for "Mommy" or "Mamma." Even the dogs heard this.

"There was always noise in the kitchen like a party," the previous owner stated. There were sounds like chairs scraping across the floor, loud laughing and lots of people. The first Thanksgiving they were there, the extended family joined them at the Samuel Tull House. A nephew went to lie down and reported that someone was knocking on the attic door. The previous owners heard the same thing. The nephew was so frightened he never went back upstairs. Later, the owner found out that the Tulls had raised fifteen children in that home, and the kids slept in the attic.

Visiting friends from New Jersey were walking through the house and went into the front bedroom. One noted that the hair stood up on the back of her neck. She wouldn't sleep in the room. She chose to sleep downstairs on the couch. The previous owners told the owner I was interviewing that their daughter was in bed one night and felt like someone was choking her.

At the end of the interview, the owner confessed that in the years they owned the Samuel Tull House, she never stayed a night in the house by herself. If she was due to be alone, she'd call a friend to spend the night or she'd go to someone else's house.

Cry Baby Bridge on East Creek

There are many bridges named "Cry Baby Bridge." Inevitably, there will be a story about some baby dying or drowning or some mother tossing her baby into the water; people in the present day hear a baby cry long after the incident. I know of four "Cry Baby Bridges" on the Eastern Shore. The story about this bridge is similar, but the legend isn't so ancient and the story hasn't changed much. And we know who the baby is.

On July 29, 1875, Eliza Conner was riding back to her home in a horse and carriage. Her four-year-old daughter, Annie, was with her. A thunderstorm was about to hit, and Eliza hurried to get home before skies broke open. As her horse began to step onto the Mill Dam Bridge, which crosses East Creek less than a mile from the Conner home, a loud clap of thunder spooked the horse; it reared up and jumped off the bridge, flinging the carriage into the rushing water. Eliza couldn't get to Annie. She heard her cries, but then they suddenly disappeared. They found Annie's remains a few days later on a bank closer to where East Creek empties into the Pocomoke Sound. Her little body had been devoured by crabs.

It's been 140 years since that awful day when little Annie Conner died, and today, East Creek has silted up. The waterway is much smaller now, but people still fish off of the bridge. It is the testimony of fishermen and neighbors near the creek that link the bridge to a child spirit. They say they can hear crying—the frantic scream of a child. It sounds far away, and then it stops all at once. So it's been named Cry Baby Bridge.

Local author Woodrow T. Wilson wrote of this tale in a news article back in the 1950s. He claimed in his book *Quindocua, Maryland* that a woman who reviewed his article, Mrs. Stella Conner Bradshaw, approached him and told him the legend was true. She said the child was her aunt (her father's sister), Annie Conner, who was born on December 10, 1871. The accident happened on July 29, 1875. The horse was frightened by a thunderstorm.

The bridge over East Creek in Marion Station, also known as "Cry Baby Bridge."

There were no railings on the bridge at the time. The carriage went over, and little Annie's body wasn't found until later.

Another confirmation of the tale surfaced during a bus tour I led touring haunted sites in Crisfield and Marion Station back in February 2010. There was a lady on my tour who said the story of Cry Baby Bridge in Marion was familiar. She recalled her grandmother talking about that bridge. She e-mailed me once she returned to her home to Virginia and said, "I remember my grandmother telling me about that child drowning. I checked with my mother who is now 91. She confirmed that Annie Conner, the child who drowned was the sibling of my great grandmother Mollie Conner."

The Conners had another tragedy twelve years later. Charles Connor, who was seven at the time, was in a store at Tulls Corner standing under a horse cart that was suspended from the ceiling. The cart broke loose and fell on top of him, crushing his little skull. He's buried next to Annie and his parents, Nathan and Eliza, at St. Paul's graveyard. Nathan and Eliza died three days apart in 1912.

THE VANCE MILES HOUSE

Since 2008, I've collected more than 150 ghost stories and am now finishing my fourth book on Eastern Shore hauntings. People always ask me how I got started writing about ghosts. I always answer the same: "I moved into a haunted house." We didn't know what to expect when strange things started happening in our house. But the majority of activity has quieted down for the most part, and we are quite at home in the Vance Miles House here in Marion Station. It would be careless of me not to tell the story about my own haunted house in the book that features sites on the Lower Eastern Shore.

When we moved from the Washington, D.C., suburbs into this beautiful Victorian home in Somerset County, we had no idea what was waiting for us. We had a warning that we didn't recognize. We had only lived here a month or so when a man from North Carolina drove into our driveway and told my husband, Dan, that he was doing genealogy research. He mentioned

The Vance Miles House, home of the author.

that his great-aunt married the man who built this house. He asked many questions, and Dan encouraged him to return when I got home from work. I was home about twenty minutes, and he came back. As I walked to meet him in the driveway, he started talking to me. He said, "The man who built this house was married to my great-aunt, Lillian, and his name was Vance Miles—and he shot himself right there in your living room."

It was an interesting meeting. Shortly after that, things began to happen. Dan and I were in the basement installing a dryer one afternoon when we heard someone open the back door and walk into the house. We heard the footsteps above us. We heard the bell ring as the door opened. Dan went upstairs, and I went out the basement door—both of us trying to see who it was. No one was there. The door remained closed…and locked. Not long after that, my daughter and I were sitting on the couch watching television. We heard a loud crash in the bedroom above us. The whole room shook. The sound woke Dan up on the second floor. We all rushed to see what it was, but there was nothing amiss—nothing except an open window in that room. It was a window that was used for an air conditioner. It had no screen. No one in Somerset County opens a screenless window, ever, as we have a lot of insects. So I know that none of us would have opened that window.

My daughter saw someone walk into the living room and heard the sound of the person moving. The dog even barked. But there was no one there. The dog used to sit and bark at that living room—the same one where the man said Vance Miles had killed himself in our house. All of our children have been pushed down our stairway at one time or another. The grandchildren would talk to people we couldn't see. One afternoon, the chandelier in the dining room started to sway. It began to go faster and faster, and when Dan reached up to steady it, a glass globe from the chandelier shot out toward the table and knocked over a full vase of two dozen roses. It was Valentine's Day.

When one of my china plates was tossed off a sideboard and broken, I finally decided that we were going to move. We hadn't been there a year and I knew that we would lose money, but I was ready. The strange events were making me crazy. I was also having tormenting dreams of being strangled and suffocated. We put the house up for sale and got a potential buyer. The couple was from Pennsylvania, and the woman loved the house. They asked lots of great questions, and they weren't contingent on selling their home, so we were optimistic the longer they stayed. Just as they were leaving, the woman asked if she could see the attic one more time. It's a fully floored attic with a vaulted ceiling. She didn't come down for a long time, and when she finally did, she started talking to her husband about our slate roof and

explaining the construction. When Dan asked her how she knew these things, she replied, "Well, your dad—I guess that's your dad—you know, the man upstairs told me about how the roof was constructed." Then she glanced up and saw him in the stairway. When she realized that we didn't see him and neither did her husband, the conversation stopped. They left. We never saw them again.

Shortly after that incident, I discussed my frantic situation with a Christian mystic who was a personal friend, as well as a psychic medium I met through working with National Geographic Television Network. They both connected with the spirits in my house. Afterward, they both said the same thing: "The spirits in your house don't want you to leave." They both said that everything would be fine from that time forward. And it was fine. All of the crazy things, the terrifying things, just stopped. We still get the occasional phenomenon—voices mostly—but we can live with them. We've learned to live with them.

Vance Miles didn't kill himself in our house. An elderly neighbor who knew Mr. Miles explained to us that he was very sick and in a lot of pain. He went fishing every day, and one of those days he ended his life while fishing. There have only been three families who have lived in this house since it was built in 1892. We feel like we belong here, that we were meant to be here in this time. We have six grown children and ten grandchildren who love to come visit. But to this day, none of our grown children will spend the night in this house if we aren't here.

AFTERWORD

I tell the tales as the tales I learned,
when the candles smoked and the back log burned.
When the gleaming light from the big fireplace
cheered the heart as it lit the face.
When life was young and home was dear
and I heard the tales I loved to hear,
Of Rhoda Clark the old witch and her famed bread tray
that she paddled with her broom over Chesapeake Bay.
How Aunt Polly told in whispered tones
of the goblins' raw head and bloody bones,
of Purnell Prospect and the headless man,
who chased her home as home she ran.

At night I heard over the wild and trackless moors,
the breaking waves on the distant shore.
I heard the black ducks quack and the seagulls scream
as they sought their prey in the winding stream,
But now the goblins are gone and witches too,
and with these tales I now am through.

—Dr. Jacob Fletcher Somers, Crisfield, Maryland, 1924

Afterword

Entrance to St. Paul's Episcopal Church and graveyard, Marion Station.

BIBLIOGRAPHY

Books

Andrews, Matthew Page. *Tercentenary History of Maryland.* Chicago: S.J. Clarke Publishing Company, 1925.

Carey, George G. *Maryland Folk Legends and Folk Songs.* Cambridge, MD: Tidewater Publishers, 1971.

———. *Maryland Folklore and Folklife.* Centreville, MD: Tidewater Publishers, 1979.

Merson, Jean Earley. *A History of McCready Hospital.* Crisfield, MD: McCready Health Services Foundation, 1998.

Peden, Henry C., Jr. *Revolutionary Patriots of Worcester & Somerset Counties, Maryland, 1775–1783.* Westminster, MD: Willow Bend Books, 1999.

Tawes, Leonard S., Captain. *Coasting Captain: Journals of Captain Leonard S. Tawes.* Newport News, VA: Mariners Museum, 1967.

Torrence, Clayton. *Old Somerset on the Eastern Shore of Maryland.* Baltimore, MD: Regional Publishing Company, 1966.

Touart, Paul Baker. *Along the Seaboard Side: The Architectural History of Worcester County, Maryland.* Snow Hill, MD: Worcester County Commissioners, 1994.

———. *At the Crossroads: The Architectural History of Wicomico County, Maryland.* Crownsville: Maryland Historical Trust and Preservation Trust of Wicomico Inc., 2008.

———. *Somerset: An Architectural History.* Annapolis: Maryland Historical Trust and Somerset County Historical Trust, 1990.

Bibliography

Townsend, George Alfred. *The Entailed Hat*. Cambridge, MD: Tidewater Publishers, 1955.

Truitt, Reginald V., Dr., and Dr. Millard G. Les Callette. *Worcester County, Maryland's Arcadia*. Snow Hill, MD: Worcester County Historical Society, 1977.

Wilson, Woodrow T. *History of Crisfield and Surrounding Areas on Maryland's Eastern Shore*. Baltimore, MD: Gateway Press Inc., 1973.

———. *Quindocqua, Maryland: Indian Country*. Baltimore, MD: Gateway Press Inc., 1980.

———. *Thirty-four Families of Old Somerset County, Maryland*. Baltimore, MD: Gateway Press Inc., 1974.

Articles and Pamphlets

Baltimore Sun. "Obituary for Mabel J. Cohen." July 7, 2006.

Bulletin of the Medical and Chirurgical Faculty of Maryland 1, no. 3. "The Creation of the State Tuberculosis Sanatorium" (September 1908).

Folklore Collection Files. Edward H. Nabb Research Center at Salisbury University, 1975.

Gibbons, Gladys I. "An Itty Bitty History of Snow Hill, Maryland." 1970. Courtesy of the Worcester County Library in Snow Hill, Maryland.

Kensey, Charles C. *The Pocomoke River, a Booklet of Personal Memoirs*. Pocomoke City, MD, 1954.

Records, Bryan, Assistant Chief. "Rock: History & Heritage." *Salisbury Fire Department Newsletter* 2, no. 1 (1st Quarter 2015). Salisbury Fire Department.

Somers, Jacob Fletcher, Dr. *Old Ailsey's Light*. Crisfield, MD, 1924.

Tyrone (PA) Daily Herald. "Judge a Suicide." August 11, 1917.

Washington Times. "Mother and Child Sought in River; Father Is Frantic." November 24, 1912.

Weinberg, Albert E. "Eastern Shore Rich in Folklore." *Baltimore Sun*, June 17, 1928.

(Wilmington, DE) Sunday News Journal. "Md. Student Dies in Fall." May 19, 1985.

Wilson, Woodrow T. "Lilyan Stratton Corbin." Private papers housed in the Crisfield Library, Crisfield, Maryland.

Bibliography

Personal Interviews

City of Crisfield staff.
Aleta Davis, chairman of Friends of Poplar Hill.
Katy Fleming and the staff from the Mar-Va Theater, Pocomoke City.
Costen Gladding, Pocomoke City.
Phillip Goldsborough, Historian, City of Crisfield.
Ron Haas, Delaware Wild Lands.
Ronnie Haymaker, Arborist, Princess Anne, Maryland.
Jon Hill, Whaleyville, Maryland.
Tim Howard, Crisfield Heritage Foundation.
Don Malloy, former Pocomoke City Councilman.
Jim Norton, Pocomoke City.
Andy Nunez, Salisbury, Maryland.
Bridget Perry, Princess Anne.
Princess Anne Police Department.
Daniel Rider, Associate Director, Maryland Forestry Service, Department of Natural Resources.
Dan Rider and Larry Walton, Maryland Department of National Resources.
Assistant Chief Bryan Records, Salisbury Fire Department.
Dana Simson, Chesapeake East, Salisbury, Maryland.
Somerset County Library—Crisfield Branch.

About the Author

Mindie Burgoyne became interested in ghost stories when she and her husband, Dan, moved into a haunted house in Somerset County, Maryland, in 2002. She began collecting ghost stories about the haunted Eastern Shore and eventually wrote *Haunted Eastern Shore: Ghostly Tales from East of the Chesapeake*, a book published by The History Press in 2009. Her readers began inquiring about ghost tours to some of the places in her book. So she organized a few bus tours and continued to collect ghost stories. In the last six years, she has collected more than 150 ghost stories and designed ten ghost walks and a series of "Ghost and Graveyard" bus tours across the Delmarva Peninsula. Eventually, she and her husband founded Chesapeake Ghost Tours and hired and trained a staff of guides who have become some of the best storytellers on the Eastern Shore. The company operates year round, providing hundreds of ghost tours from Easton to Ocean City.

With ghost tour guests asking for more written stories to have as a memento of their ghost tours, Mindie began writing a three-book haunted trilogy on the Eastern Shore in the areas that cover the ghost walks. In October 2014, The History Press published the first book in that series, *Haunted Ocean City and Berlin*. The following year, The History Press published the second book in the series, *The Haunted Mid-Shore: Spirits of Dorchester, Caroline and Talbot Counties*. This book completes the trilogy. Mindie continues to roam the Delmarva Peninsula, scouting out new haunted locations and interviewing the locals about ghosts, spirits and folklore.

About the Author

Chesapeake Ghost Tours is a subsidiary of Travel Hag Tours, the Burgoynes' travel company. Under this brand, they offer custom tours designed for those who want a travel experience that feeds the mind, body and spirit. They offer tours every year to Ireland's mystical places and sponsor a travel club for girlfriends in the United States.

By day, Mindie works full time for the State of Maryland doing rural economic development, assisting Eastern Shore businesses and local governments by connecting them with resources that will help grow the economy. She also serves on the Edward H. Nabb Research Center's Advisory Board at Salisbury University.

Mindie and Dan Burgoyne have six children and ten grandchildren. They love the outdoors and spend most of their free time traveling. She writes from their home in Marion Station, Maryland, and serves as a board member on the Lower Eastern Shore Heritage Council.